Contents

Foreword

Judith Ellis Glickman and her husband, Albert Glickman, have been among the most enthusiastic and long-time supporters of the Portland Museum of Art. Judy's tireless efforts on behalf of the Photographic Advisory Committee have helped raise funds for the acquisition of photographs for the collection and, more importantly, raise awareness of the role of photography in our lives. For the past decade, she has placed works from her collection on long-term loan to the Museum, and we have been fortunate to dip into the collection to augment various photography exhibitions about Maine ranging from *Recollected Images: Chansonetta Stanley Emmons* in 2000 to *Maine: The Way Life Is* in 2006.

This exhibition, however, offers the first opportunity to examine the remarkable breadth and depth of Judy's collection. It is all the more important because it places the history of Maine photography within the larger context of world photography. The exhibition also offers Museum visitors an opportunity to comprehend the collective power of photographic images, not as individual works, but as elements of an important humanist narrative envisioned by the collector. As both a collector and maker of photographs, Judy Glickman is in a unique position to help us understand what makes these specific images work both formally and emotionally. The Portland Museum is deeply indebted to Judy for her generosity and her passion for the art of photography.

We are also grateful to a group of Judy's friends and family who have made this wonderful catalogue possible. Leonard Nelson spearheaded the fundraising efforts, and the Portland Museum especially appreciates the contribution from his law firm, Bernstein, Shur, Sawyer, and Nelson. Additional support for the catalogue comes from Charlton and Noni Ames, Scott and Isabelle Black, Joe and Sheri Boulos, the Richard Ellis Family, the Thomas Ellis Family, Barbara and Howard Goldenfarb, Peter Haffenreffer and Mallory Marshall, Chris and Betsy Hunt, Harry and Susie Konkel, Robert and Elizabeth Nanovic, Kenny and Mary Nelson, Lenny and Merle Nelson, Nelson Rarities, Inc., and the Melissa and Matthew Rubel Family. This catalogue serves as a lasting tribute to their generosity and to Judy Glickman's endeavors as a collector.

Daniel E. O'Leary
Director

Edward Sheriff Curtis, *The Fisherman, Wisham*, 1904

Both Sides of the Camera: Photographs from the Collection of Judith Ellis Glickman

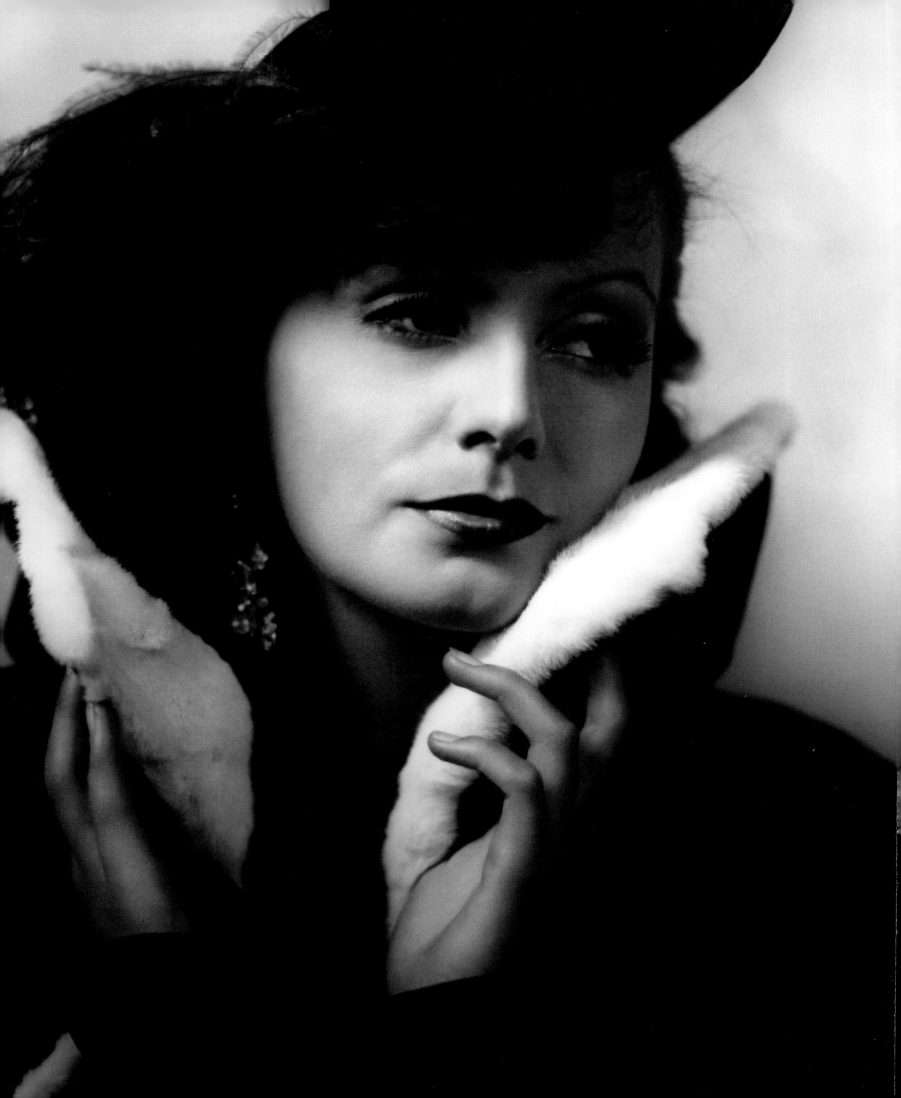

Both Sides of the Camera:

Photographs from the Collection of Judith Ellis Glickman

Portland Museum of Art, Maine, 2007

This book was published in conjunction with the exhibition *Both Sides of the Camera: Photographs from the Collection of Judith Ellis Glickman* October 25, 2007–January 6, 2008

Edited by Amber Degn
Designed by Margo Halverson, Charles Melcher, Alice Design Communication, Portland, Maine
Production by Sandra Klimt, Klimt Studio, Inc., Falmouth, Maine
Digital captures and separations by Thomas Palmer, Newport, Rhode Island
Typeset in Scala Sans and Goudy Oldstyle
Printed in China

The exhibition and accompanying catalogue have been made possible by Bernstein, Shur, Sawyer, and Nelson, with additional support from Charlton and Noni Ames, Scott and Isabelle Black, Joe and Sheri Boulos, the Richard Ellis Family, the Thomas Ellis Family, Barbara and Howard Goldenfarb, Peter Haffenreffer and Mallory Marshall, Chris and Betsy Hunt, Harry and Susie Konkel, Robert and Elizabeth Nanovic, Kenny and Mary Nelson, Lenny and Merle Nelson, Nelson Rarities, Inc., Daniel O'Leary, and the Melissa and Matthew Rubel Family.

Library of Congress Control Number: 2007929294
ISBN 9780916857479

Cover: Barbara Morgan, *Spring on Madison Square*, 1938

Frontispiece: George Hurrell, *Greta Garbo*, 1930

This page: Judith Ellis Glickman, *Snow Geese, Quebec*, 1998

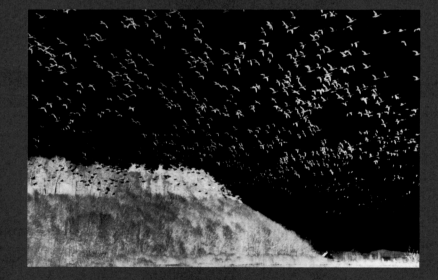

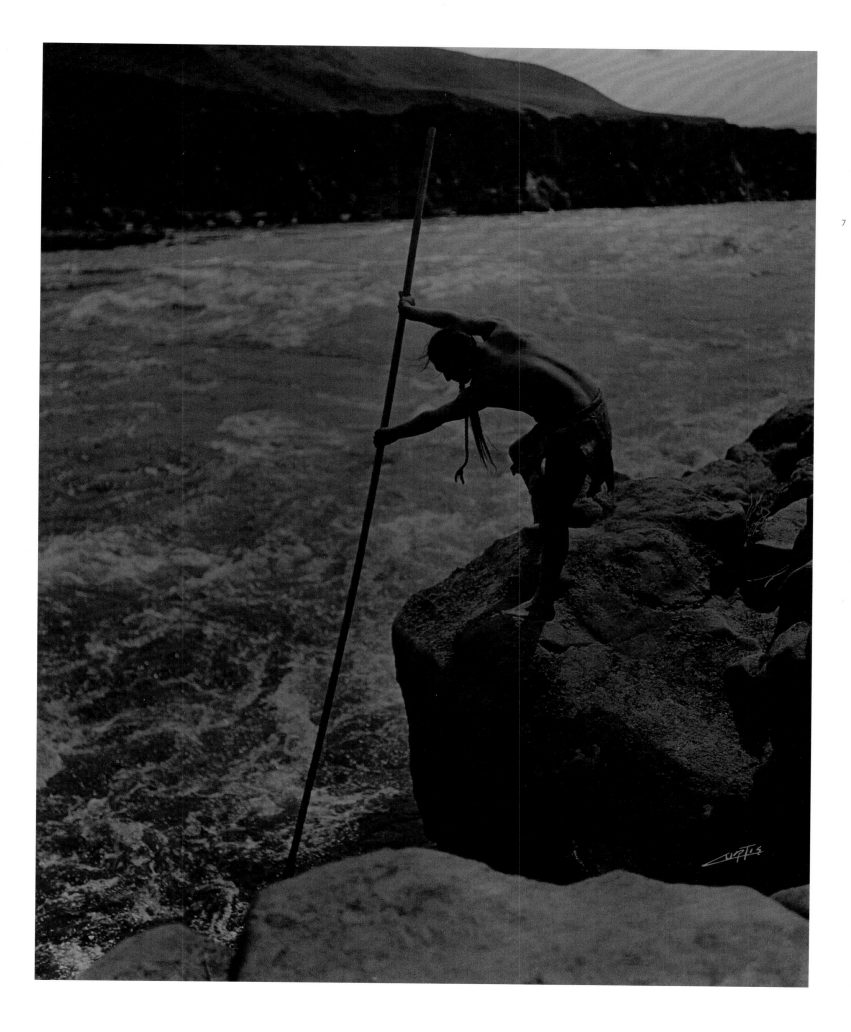

It has been said that every image a photographer takes is in some way a self-portrait. Perhaps every image that a photographer collects can also be considered a self-portrait.

Judith Ellis Glickman

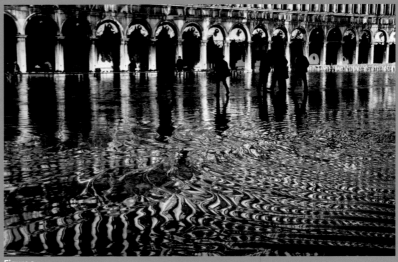
Figure 1

Figure 1. Judith Ellis Glickman, *Venice*, 1997
Figure 2. Irving Bennett Ellis, *Judy Ellis posing with her father*, circa 1945

Introduction

Figure 2

As an ardent photographer and collector, Judith Ellis Glickman brings a special perspective to the art of the camera. She has long been on both sides of a camera lens—both posing for pictures and making her own images (Figs. 1, 3, 4, 5, 7). This exhibition explores how that unique experience has shaped her collecting interests over the years. Judy's love of the medium dates back to her early childhood days when she stood in front of her father's camera as he created a pictorialist vision of idyllic youth in Northern California.[1] Later, as a college student at the University of California in Los Angeles (UCLA), Judy enrolled in courses in art history, served as a docent at the Frederick S. Wight Art Gallery, and eventually took classes with the innovative photographer Robert Heinecken.[2] She bought her first single-lens reflex camera with her father, a year before he died, and began taking family photographs. For nine of the following summers, Judy traveled east to the Maine Photographic Workshops where she honed her darkroom skills and studied with some of the nation's leading photographers, including Joyce Tenneson (Fig. 4), Arnold Newman, and Eugene Richards. Today she continues to divide her time between the East and West Coasts, and her growing photography collection reflects that central cultural dichotomy of her life.

The first photograph that Judy acquired, Jerry Uelsmann's *Small Woods Where I Met Myself* (Plate 108), reflects her own interests as a photographer as well as the orbit of West Coast photography collecting. In many ways it also can be read as a metaphor for a life in photography where Judy "met herself." She first encountered the image at an exhibition of Graham Nash's photography collection at UCLA in 1978.[3] Nash, the celebrated musician, is also an avid photographer (Plate 76), proponent of digital printing, and a collector. Among the works from his collection sold in 1990 at a Sotheby's auction were photographs by Julia Margaret Cameron, Diane Arbus, Ansel Adams, and Henri Cartier-Bresson. Uelsmann's *Small Woods Where I Met Myself* (Plate 108) incorporates many elements that would later appear in Judy's own work or in the photographs that she collects. Judy's interest in infrared photography and her photographs of Great Diamond Island in Maine where she summers (Fig. 5) reflect the influence of Uelsmann's experimental printing techniques and mysteriously romantic landscape settings. In addition, the focus on the nude in her own collection can be traced back to Uelsmann's work.[4]

As she began to collect, Judy attended informal photography discussion sessions at Edmund Teske's studio in Los Angeles. Teske was known for his experimental printing techniques such as duotone solarization and the use of composite negatives (Plate 34).[5] Eventually she bought three prints by Teske, each incorporating the kind of technical innovation he used to suggest otherworldly effects. The softened, atmospheric tones in his work are echoed by the tonal effects in Glickman's infrared photographs (Fig. 5). At this time, Judy also began to visit the galleries of Los Angeles photography dealers G. Ray Hawkins and Stephen White. At Hawkins's gallery she met George Hurrell, the Hollywood portrait photographer (Frontispiece, plates 71, 72, and 84), and Max Yavno, who worked in a documentary mode (Plate 10).

Like many West Coast collectors, Judy also looked to the photographic community up the coast in Carmel, California. Her father had known Edward Weston, one of Carmel's most famous photographers in the 1940s, and had taken Judy and the family to visit Weston at Point Lobos. Ellis had paid homage to Weston's pioneering work in landscape photography with his own view of California sand dunes (Fig. 6), and one of Judy's early purchases was a classic Edward Weston nude of Charis Wilson (Plate 9). This image serves as a tribute to both her father and Weston—photographers who represent the two poles of the California art photography movement in the first half of the 20th century—pictorialism and straight photography. At this time, Judy also took advantage of the print purchase programs organized by The Friends of Photography in Carmel. Among the works that she purchased through The Friends program are images by Robert Dawson (Plate 22), Sally Mann (Plate 61), and Jerry Uelsmann (Plate 40). In addition to supporting the work of contemporary photographers, this

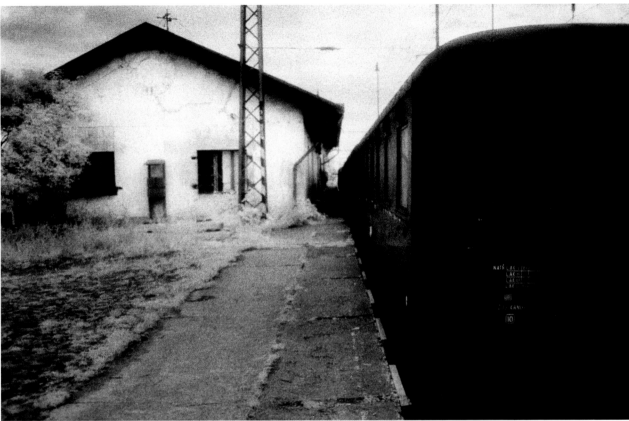

Figure 3

Figure 3. Judith Ellis Glickman, *Bohusovice Train Station at Theresienstadt, Czechoslovakia,* 1991
Figure 4. Judith Ellis Glickman, *Joyce Tenneson,* 1983
Figure 5. Judith Ellis Glickman, *Reflection,* 1995

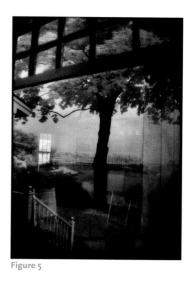

Figure 4 Figure 5

important organization also played an instrumental role in educating collectors about the history of photography, a field that had only just begun to receive scholarly and curatorial attention in the mid-1970s. As a result, Judy began to look at an older generation of California photographers—Imogen Cunningham (Plate 5), Dorothea Lange (Plate 8 and 41), and Ruth Bernhard (Plate 90, 100)—who were her father's contemporaries. Her collection also concentrates on a younger generation of Californians, among them Linda Connor (Plate 20), Judy Dater (Plate 92), Richard Misrach (Plate 24), and Reed Thomas (Plate 26).

As a photographer working on the East Coast, Judy has developed a strong allegiance to both nationally known photographers who work in Maine and the local photographic community. Through Aucocisco Gallery in Portland, she became aware of the work of George Daniell, whose life and photographic subjects also took him from Maine to California. A celebrity portrait photographer, Daniell concentrated on Hollywood stars and famous artists (Plate 82 and Page 143). Another well-known photographer who retired to Maine in the 1980s was Todd Webb, and Judy discovered his work through the Evans Gallery in Portland. His insightful portraits of Harry Callahan (Plate 88), Man Ray (Plate 80) and Georgia O'Keeffe (Plate 89) soon became part of Judy's pantheon of stars—the central focus of her collecting interests.[6]

Judy frequently adds to her collection by supporting the fundraising activities of local art organizations in Maine, such as the Maine College of Art and the Bakery Photographic Collective in Portland, through which she has purchased work by Peter Shellenberger (Plate 105), Scott Peterman (Plate 23), and Justin van Soest (Plate 28). She frequently buys or exchanges prints with her colleagues, including Melonie Bennett (Plates 49, 50, and 107), Denise Froehlich (Plate 62), Barbara Goodbody (Plate 86), and Tonee Harbert (Plate 66). Over the years, Judy has also made an effort to collect the work of prominent photographers affiliated with the Maine Photographic Workshops in Rockport, including Paul Caponigro (Plates 18 and 19), Mary Ellen Mark (Plates 51 and 52), Arnold Newman (Plates 83 and 87), Joyce Tenneson (Plate 99) and Kate Carter (Plate 56).

A third locus of Judy's collecting interest is centered in New York, especially with a group of photographers represented by the Howard Greenberg Gallery that includes Roman Vishniac (Plate 64), Elmer Fryer

(Plate 73), and Edward Steichen (Plate 70). On rare occasions, Judy has also purchased works for her collection at auction in New York, notably iconic images by Edward Curtis (Page 7), Paul Outerbridge (Plate 109), and Margaret Bourke-White (Plate 2). Because of a shared concern for the humanist issues raised by photojournalism, Judy's collecting interests and her philanthropic activities often coincide. As a current board member of the Aperture Foundation in New York, Judy supports their efforts to "foster the exchange of ideas among audiences worldwide" and she does so in many ways—in her own work dealing with the Holocaust, in the broad and eclectic taste of her photography collection, and in the works selected for this exhibition and catalogue. Over the years, Judy has purchased Aperture's limited-edition portfolios of works by Paul Strand (Plates 7 and 11) and Edward Steichen (Plates 4 and 6), as well as their *50th Anniversary Founders and Friends* set, which includes seminal images by photographers who have had a close association with the organization such as Dorothea Lange, Barbara Morgan, Paul Strand, Edward Weston, and Minor White. Another important portfolio purchase, *New York Portfolio I*, was produced in 1998 as a fundraiser by *Mother Jones*, an independent, left-wing, San Francisco magazine. The portfolio features scenes of New York City by well-known photographers including Ralph Gibson (Plate 33), Mary Ellen Mark (Plate 52), and Inge Morath (Plate 67).

Taken together, these portfolios raise some important issues regarding Judy Glickman's concerns as a collector. First and foremost she is attracted by a specific image, especially works that convey a fundamentally humanist message. She primarily collects black-and-white prints that are traditional in size, usually no larger than 16 x 20 inches. As long as the print is of fine quality, she does not always have to have a vintage image. As she has said, "It has to be a beautiful print. I have to see it and I never buy sight unseen. No matter what the subject, it has to work for me as an outstanding image—it has to come together."[7] For Judy Glickman, as both a photographer and a collector, a great photograph must express some basic human element—an emotion, a social or family relationship, religious belief, the beauty and sensuality of the human body, or the interface between the landscape and the man-made world.

In much of her own work, it is the overwhelming impact of the Holocaust that inspires her vision (Page 10, Fig. 7). She hopes that

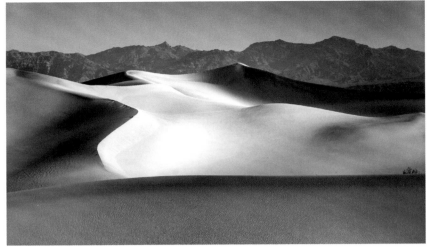

Figure 6

by "exposing the hate and evil of that dreadful moment in history, photography can in some measure teach tolerance, respect for difference, and understanding." In her collecting efforts, the role of religion and history is less specific, but nonetheless present. It may appear as the light at Stonehenge captured in a photograph by Paul Caponigro (Plate 19), in Linda Connor's view of a remote mountain-top monastery in India (Plate 20), in a scene of a river baptism in Mississippi by Ken Light (Plate 47), or in Roman Vishniac's poignant portrait of a Jewish grandfather and granddaughter on the eve of World War II (Plate 64). A deeply spiritual quality pervades much of her collection, along with a firm belief that in spirituality lies a fundamental tie that binds humankind together.

In this selection of just over 100 representative works from Glickman's collection, there is an equal distribution of works by East and West Coast photographers, although contemporary photographs outnumber historic images by two to one. A recent project to catalogue her father's work in California from the 1930s through the 1950s has resulted in a corresponding effort to acquire earlier work by Maine photographers, such as Francis Libby's gum-bichromate prints (Plate 32), Chansonetta Emmons's hand-colored lantern slides, and black-and-white prints by photojournalists Verner Reed and Kosti Ruohomaa (Plates 60 and 38). Like many collectors, however, Judy Glickman did not begin acquiring

photographs with such specific goals in mind. She bought images that drew her attention, photographs she could afford, and pictures she felt she could not live without. No one theme, historic period, or type of photography directed her to a particular gallery or photographer, a trait she shares with other contemporary collectors.[8]

In discussing ways to organize this exhibition, however, several subject categories emerged that helped make visible the humanist thread that underlies the collection. Some of the subjects are serious, some are light-hearted, and others simply defy rigid categorization. Moreover, to fully understand Judy's collection, it is necessary to see it within the context of her own work and that of her father's. Acknowledging the fundamentally subjective nature of the collecting process, Judy Glickman readily concedes that in some way these photographs constitute a "self-portrait." The groupings in the plates that follow therefore highlight the process of self-discovery—making formal connections among unrelated works and revealing a deeper understanding of the humanist spirit of photography first experienced by the collector and now shared with the viewer.

Susan Danly
Curator of Graphics, Photography, and Contemporary Art

Figure 6. Irving Ellis Bennett, *Untitled*, circa 1936
Figure 7. Judith Ellis Glickman, *Auschwitz*, 1998

[1] For a discussion of Ellis's work see Susan Danly, et al, *Irving Bennett Ellis: Amateur Photography, Advertising, and the Family* (Portland, ME: Judith Ellis Glickman, 2007).

[2] Heinecken's contribution to the field of photography is discussed in James Welling, "A Fine Experiment, A Tribute to Robert Heinecken," exhibition brochure, (Los Angeles, UCLA Hammer Museum, 2006).

[3] See Graham Nash and Susan Nash, eds., *The Graham Nash Collection* (Los Angeles: Nash Press, 1978).

[4] For an overview of his work see, Jerry N. Uelsmann, *Jerry N. Uelsmann—Twenty-five Years: A Retrospective* (Boston: New York Graphic Society, 1982).

[5] Teske's work has been featured in two exhibitions at the J. Paul Getty Museum: *Being and Becoming: Photographs by Edmund Teske*, Malibu, 1997; reviewed by Darwin Marable, "Edmund Teske, 1911–1996," *Afterimage*, 24 (May–June 1997), 3–4; and *Spirit into Matter: The Photographs of Edmund Teske*, 2004, organized and accompanied by a catalogue of the same title by Julian Cox .

[6] Todd Webb's entire career is the focus of his book, *Looking Back, Memoirs and Photographs* (Albuquerque: University of New Mexico Press, 1991).

[7] "The past 30 years have been serious years of growth, of self-discovery, of finding myself, sometimes lost in the many roles of daughter, wife, mother, friend, and community worker. My photography collection helps define me as a person, as an artist, and as a photographer. I try to be open in my work as a photographer and as a collector. I try to discover why I am drawn to a particular image, to free myself, not to pre-judge or to predetermine my choices." Judith Ellis Glickman, conversation with author, January 2007 .

[8] The speakers at a recent symposium organized by the Aperture Foundation, *A Passionate Eye: Conversations Between Photography Collectors and Curators/Critics* (October 15, 2006), emphasized just how diverse contemporary collectors are in their choice of photographers and subject matter. Few began with any fixed idea of collecting areas and only endeavored to refine such ideas as their collections grew.

Figure 7

To collect photography is to collect the world.

Susan Sontag

1. Peter Ralston, *Pentecost*, July 1983

Plates

The Classics Photography, as defined by Beaumont Newhall in his well-read *History of Photography from 1839 to the Present*, traditionally discusses the medium by identifying the masterworks of individual photographers. Some collectors begin by acquiring such designated "classic" works as acknowledged trophies. While historic works of undeniable power, beauty, and even poetry, such as famous images by Margaret Bourke-White, Dorothea Lange, and Edward Weston, populate the Glickman collection, they do not define it. Instead, they serve as touchstones for a pervasive diversity and eclecticism that goes beyond a simple list of greatest hits.

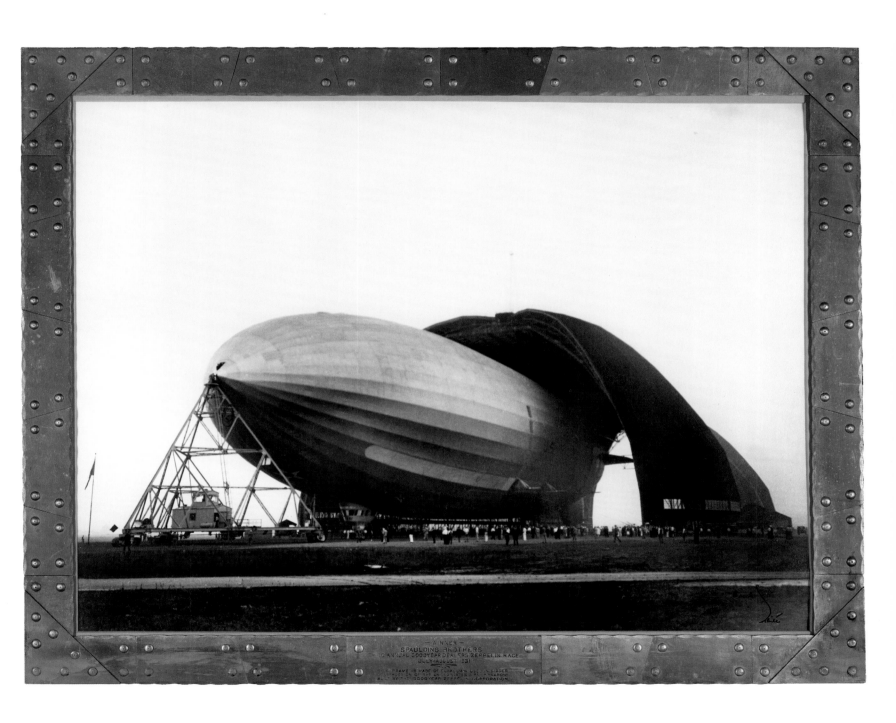

2. Margaret Bourke-White, *United States Airship Akron,* 1931

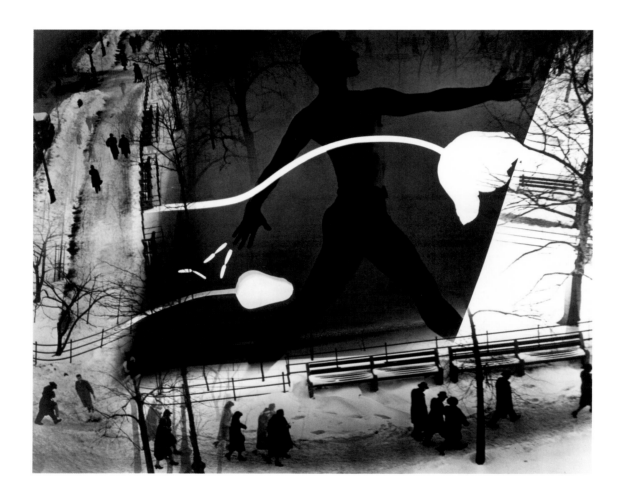

3. Barbara Morgan, *Spring on Madison Square*, 1938

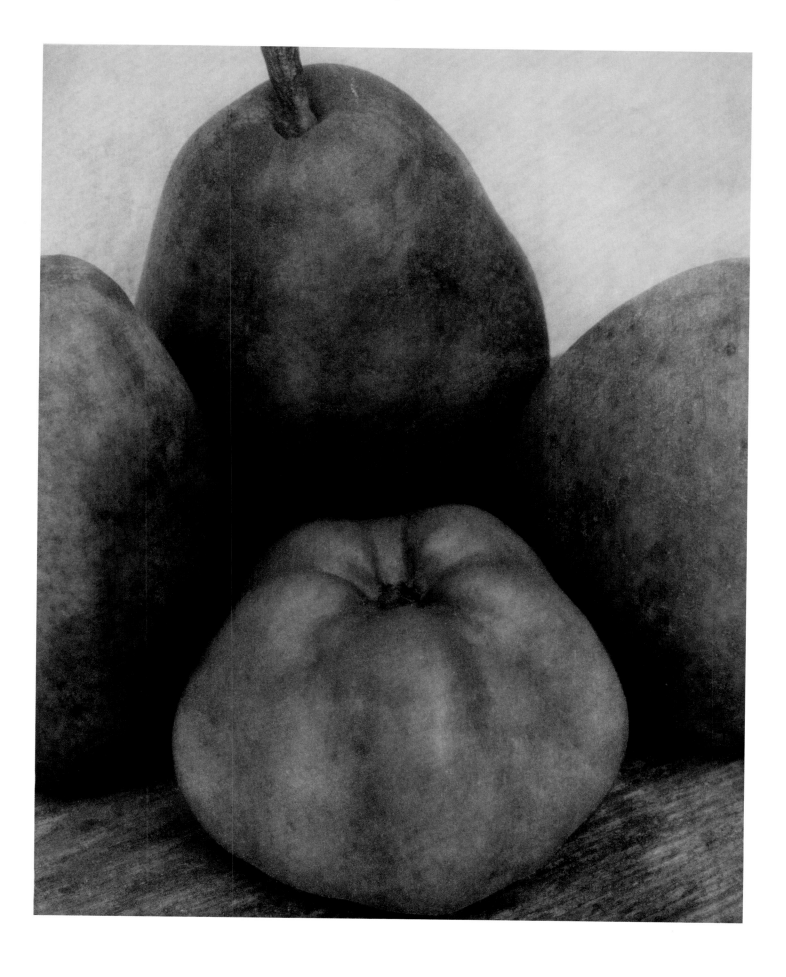

4. Edward Steichen, *Three Pears and an Apple, Paris,* 1921

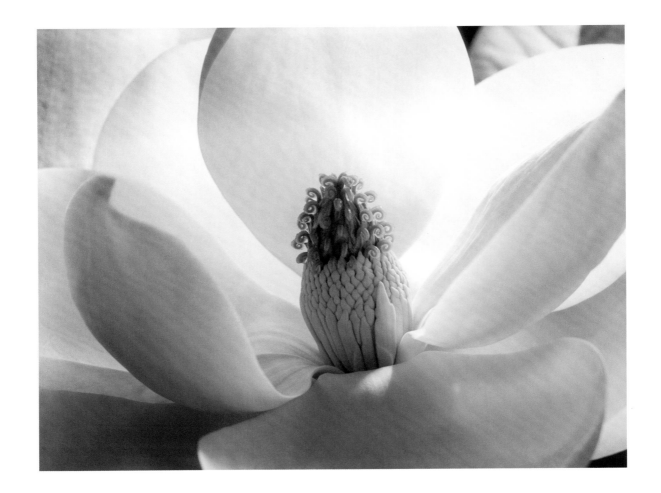

5. Imogen Cunningham, *Magnolia Blossom*, 1925

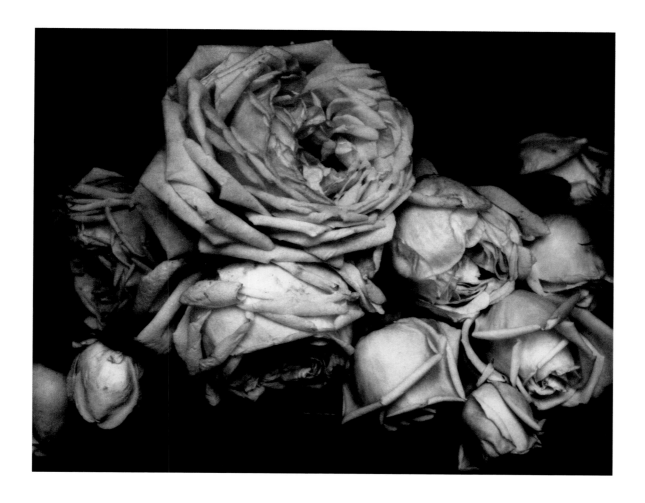

6. Edward Steichen, *Heavy Roses, Voulangis, France,* 1914

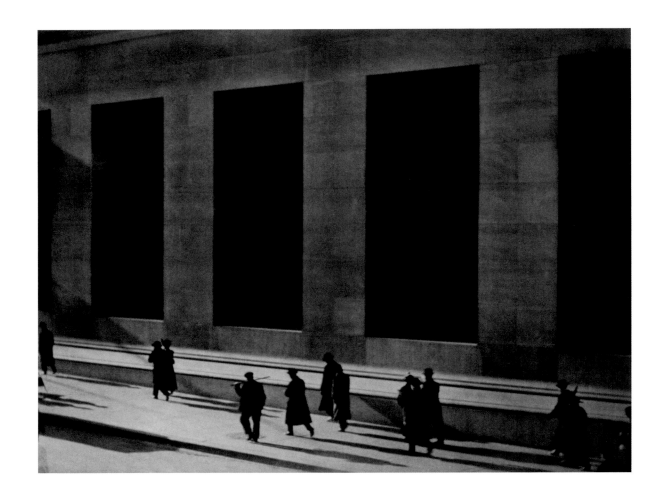

7. Paul Strand, *Wall Street, New York*, 1915

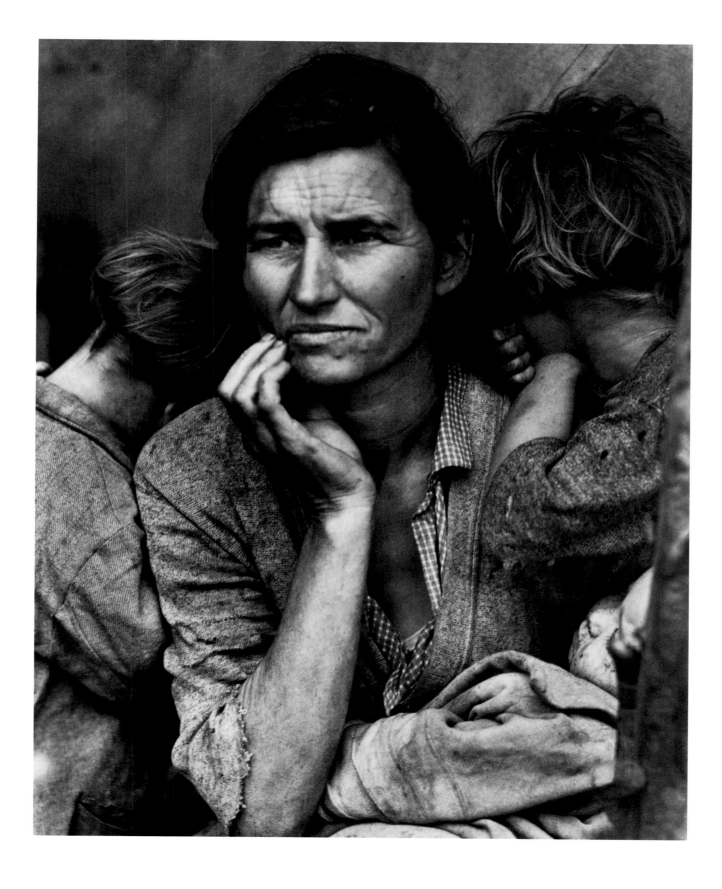

8. Dorothea Lange, *Migrant Mother, Nipomo, California,* 1936

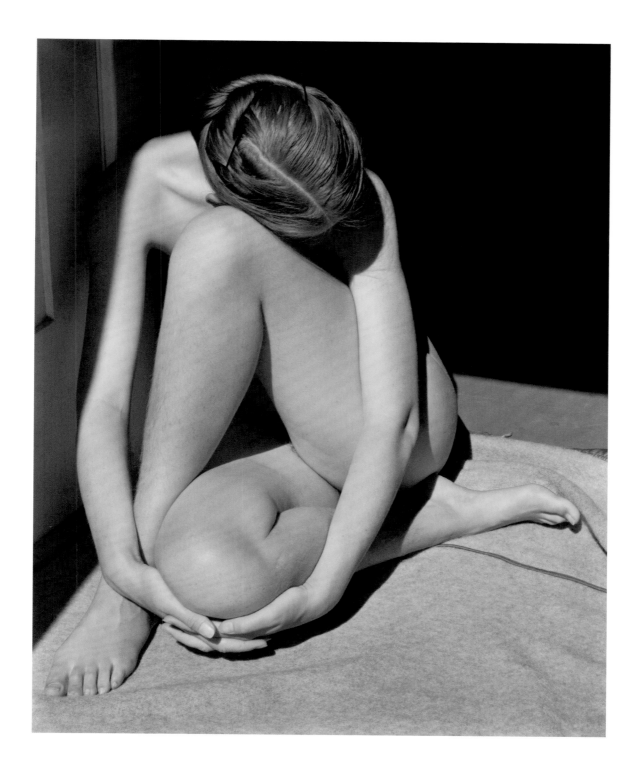

9. Edward Weston, *Nude*, 1936

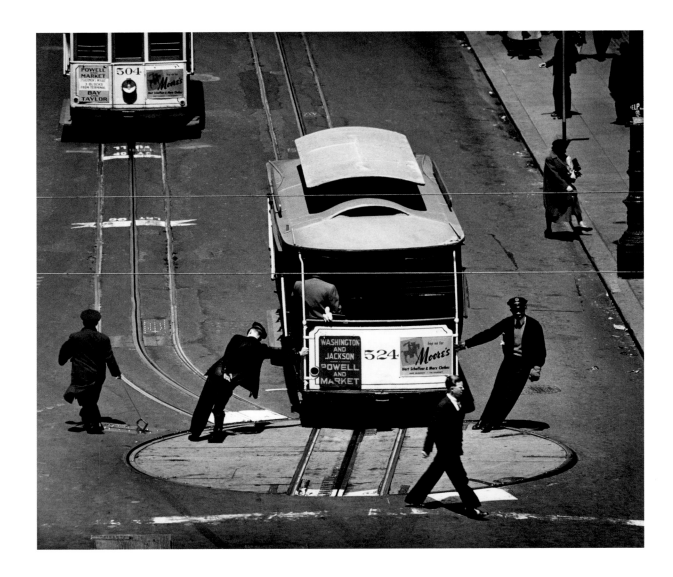

10. **Max Yavno**, *Cable Car, San Francisco*, 1947

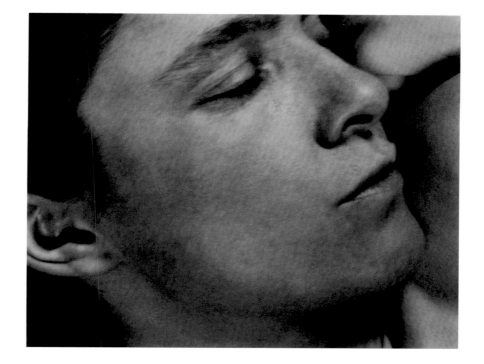

11. Paul Strand, *Rebecca*, 1923

Irving Bennett Ellis As a highly gifted amateur, Irving Bennett Ellis, Judy Glickman's father, set high standards for aesthetics and dedication to his practice of art photography. A chiropractic doctor by profession, Ellis spent almost three decades of his life photographing his family, especially his daughter Judy, at their home in Piedmont, California. His pictorialist landscapes and portrait studies won him numerous prizes and commercial recognition during his lifetime.

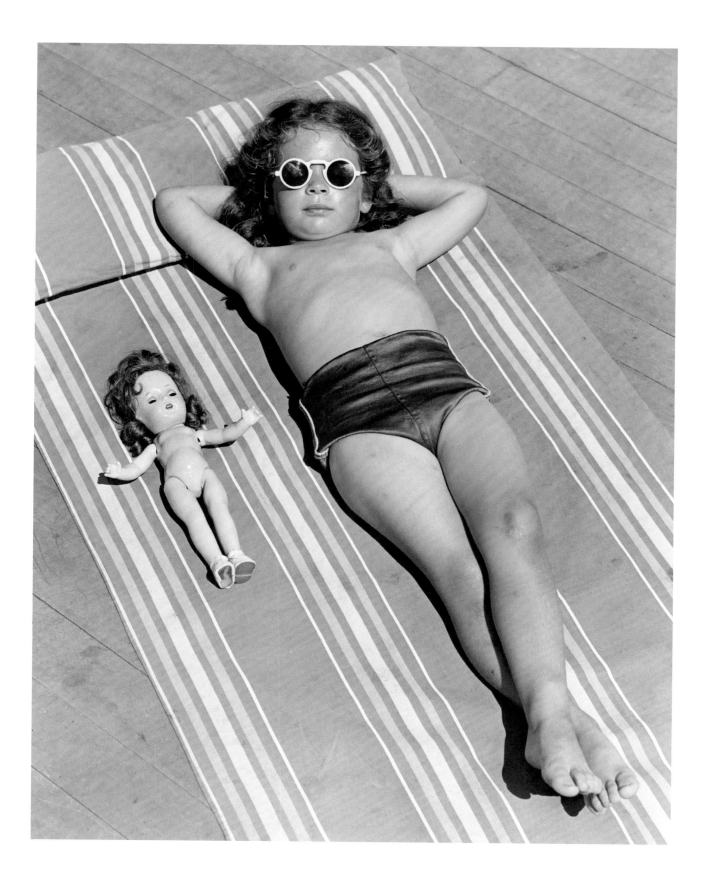

12. Irving Bennett Ellis, *Siesta*, 1942

13. Irving Bennett Ellis, *Art in Sunlight*, 1930

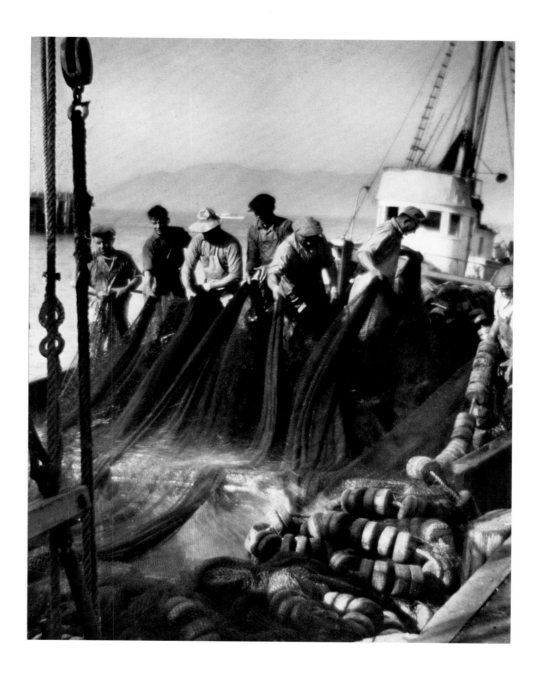

14. Irving Bennett Ellis, *Washing Their Nets at Fisherman's Wharf*, 1932

15. Irving Bennett Ellis, *Puzzles*, 1929

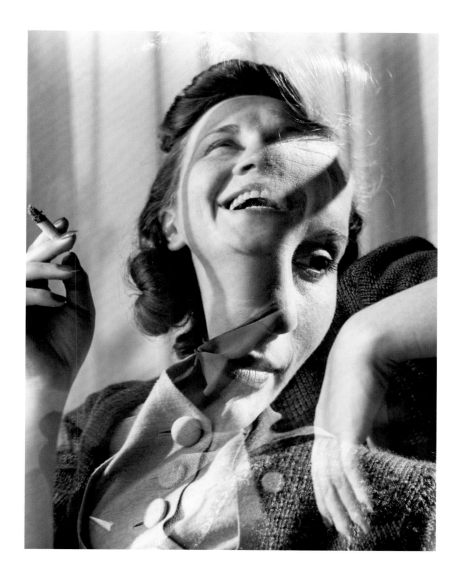

16. Irving Bennett Ellis, *Untitled* [Louise Weinberg Ellis], circa 1936

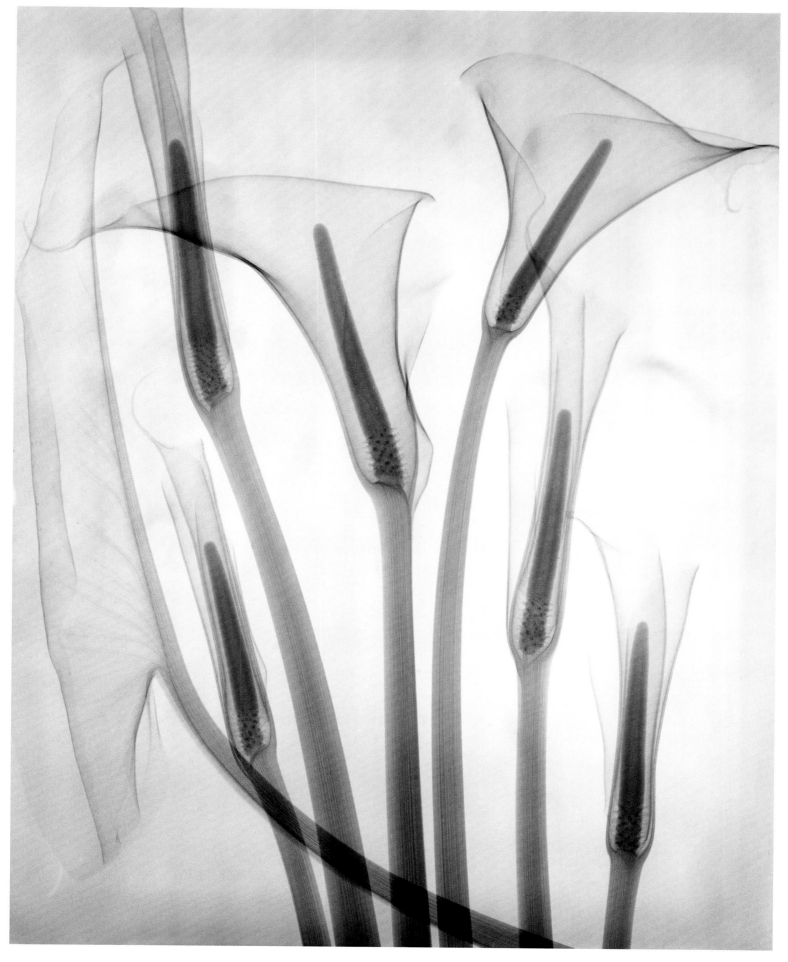

17. Irving Bennett Ellis, *X-rays*, circa 1933

Inside and Outside One of the larger groupings of works in the Glickman collection, these photographs of the landscape and the built environment are frequently permeated by special effects of light. Dawn and dusk, reflections on water, cloud-filtered sun, rays of light through large windows, pin-hole cameras, and natural and artificial light all give a spiritual dimension to our environment.

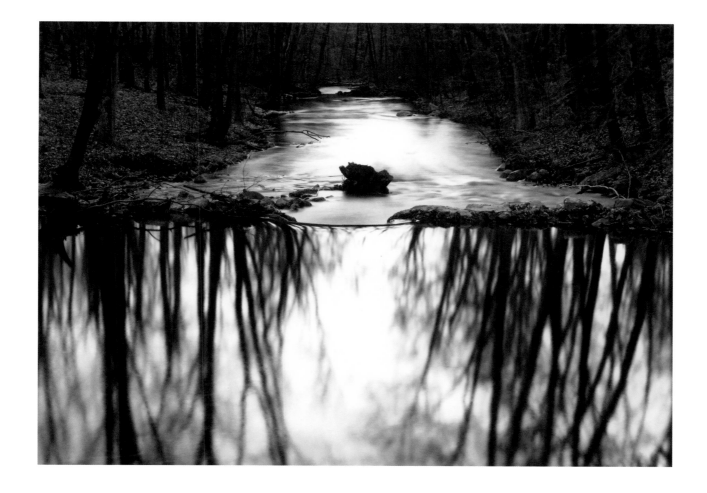

18. **Paul Caponigro**, *Reflecting Stream, Redding, Connecticut*, 1968

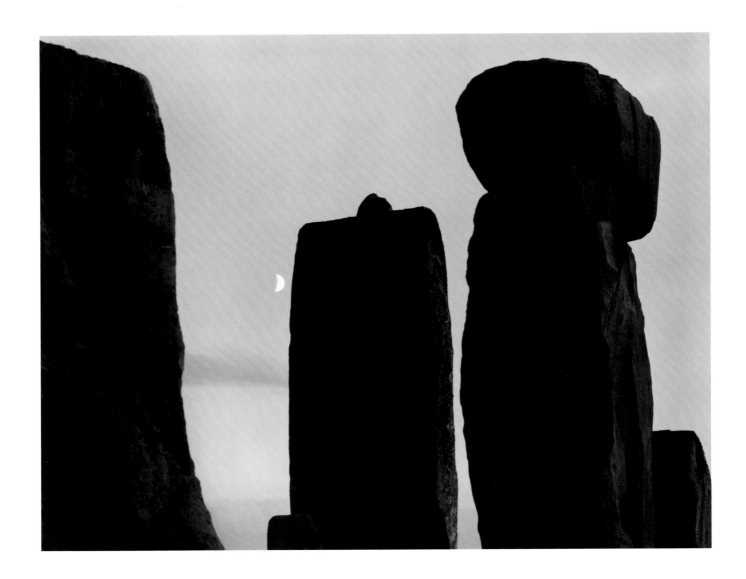

19. Paul Caponigro, *Untitled*, 1967–72, from *Stonehenge Portfolio*, 1978

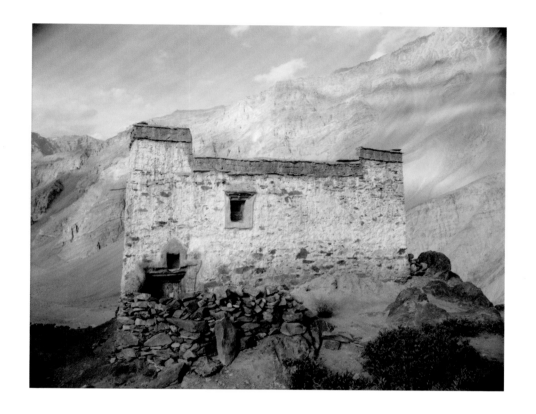

20. **Linda Connor,** *Monk's Residence, Zanskar, India,* 1985

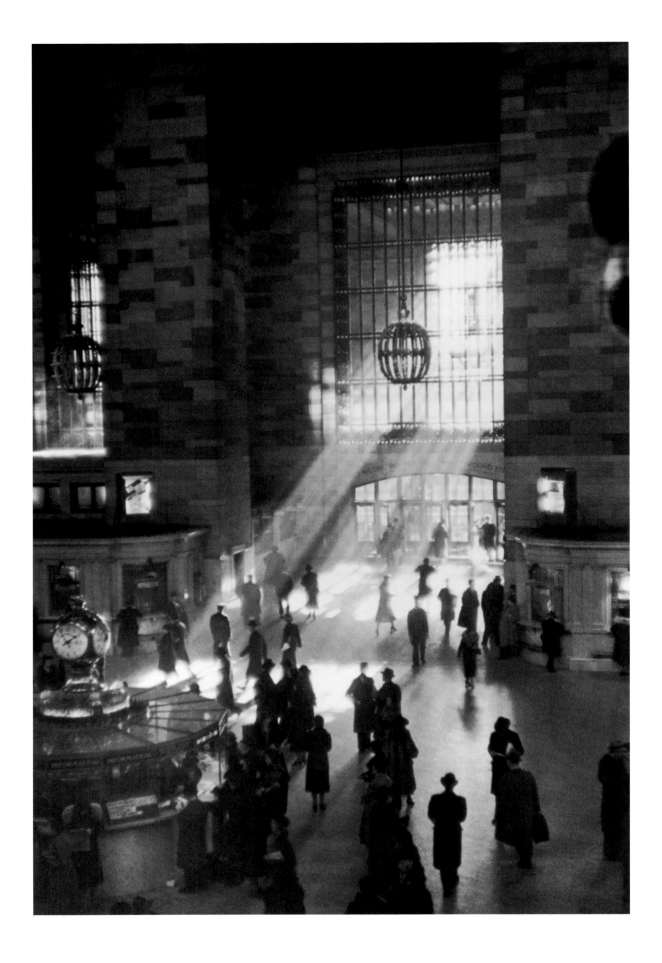

21. **George Daniell**, *Untitled* [Grand Central Station, N.Y.], undated

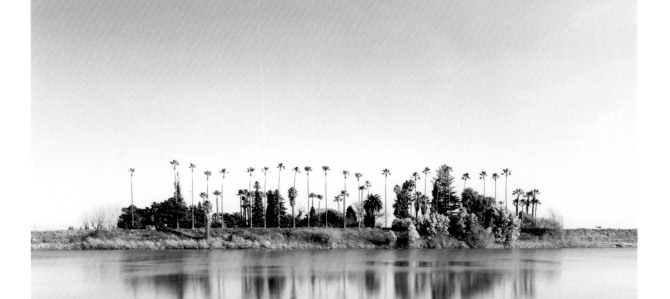

22. **Robert Dawson,** *Delta Farm, Sacramento River,* 1984

23. **Scott Peterman,** *Long Beach,* circa 2001

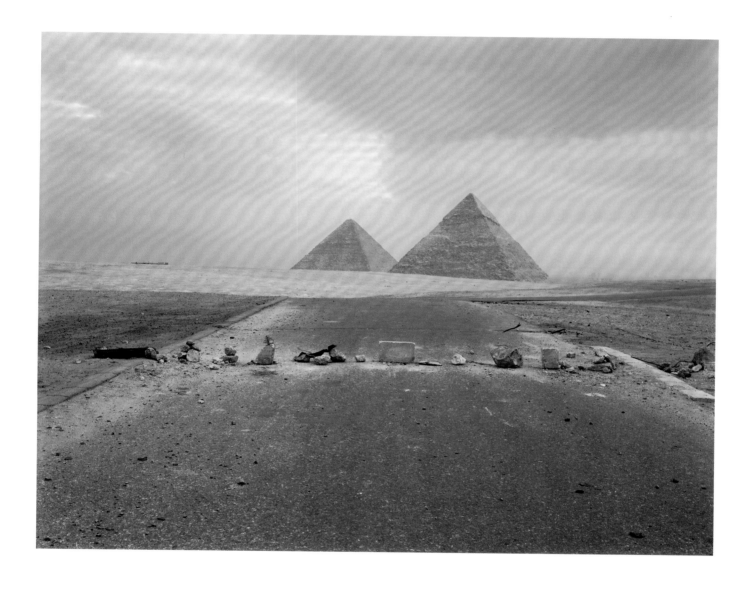

24. Richard Misrach, *Road Blockade and Pyramid*, 1989

44

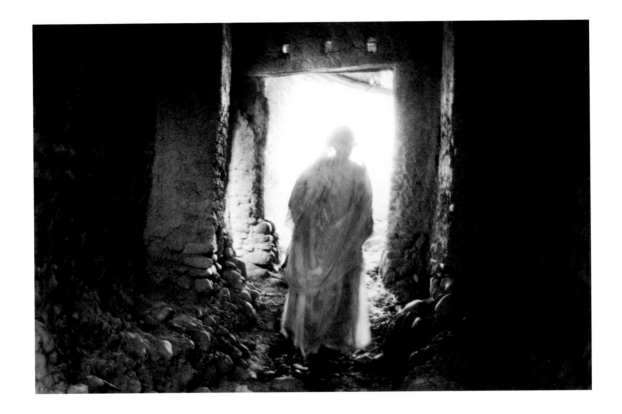

25. Rose-Lynn Fisher, *Woman in Passage*, 1998

26. **Reed Thomas,** *Ghost and Door, Pescadero,* circa 1978

27. Philip Isaacson, *Havelli in Mandawa, Western Rajistan, India,* 1991

28. Justin Van Soest, *Women's Powder Room, Radio City Music Hall,* 1999

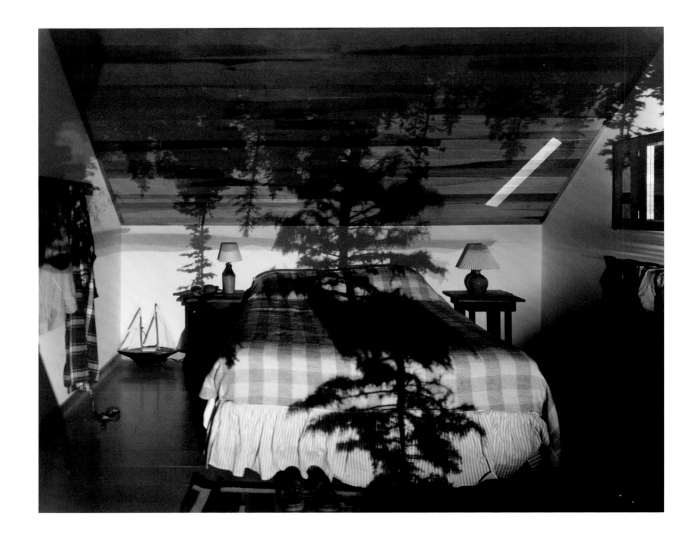

29. **Abelardo Morell,** *Camera Obscura Image of a Pine Tree in Bedroom, Little Deer Isle, Maine,* 1999

30. **Michael Kenna**, *Angelus, Vezelay, Burgundy, France*, 1993

31. Michael Kenna, *Wave, Scarborough, Yorkshire, England*, 1981

32. **Francis Orville Libby,** *Nocturne—Pathway of the Moon,* 1917

33. Ralph Gibson, *New York*, 1968

34. Edmund Teske, *Box Canyon*, 1972

35. Denny Moers, *Poetic Origins in Mexico #1, 1982*

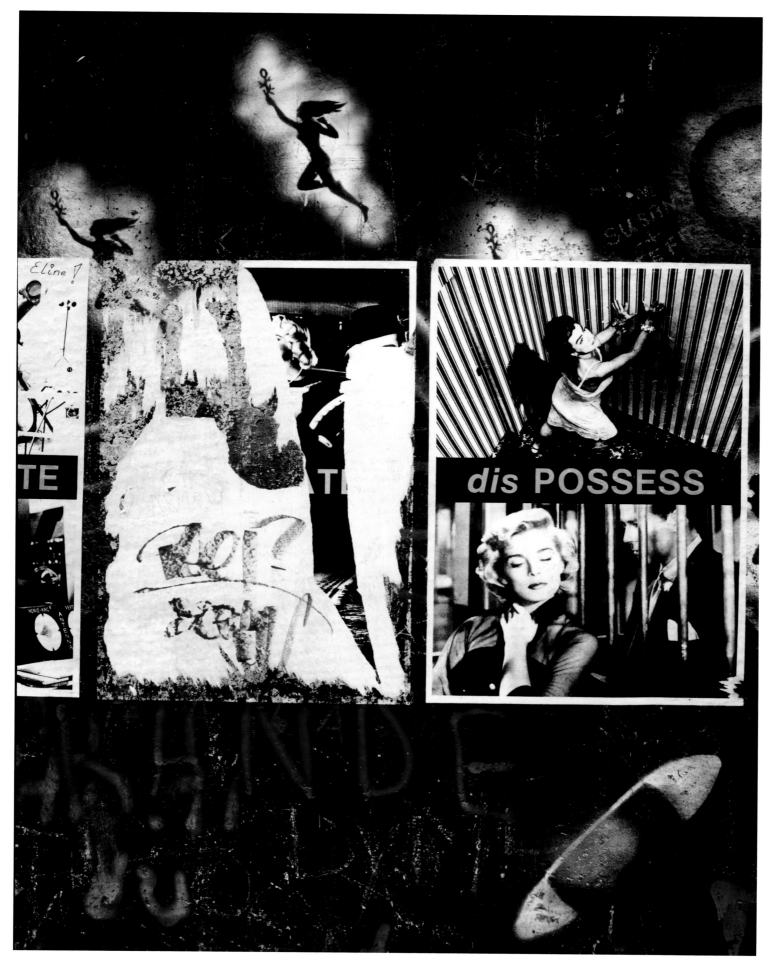

36. Leland Rice, *dis POSSESS*, 1987–1990

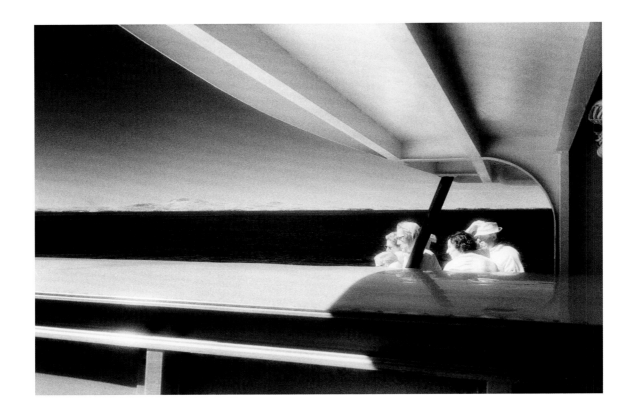

37. Sharon Fox, *Vinalhaven Ferry, Rockland, Maine*, 1979

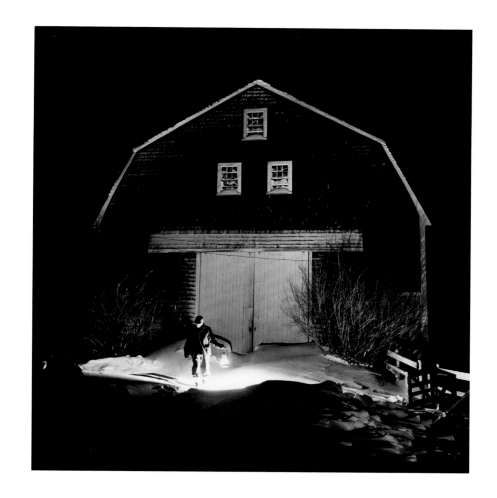

38. **Kosti Ruohomaa,** *Night Scene with Barn,* circa 1951

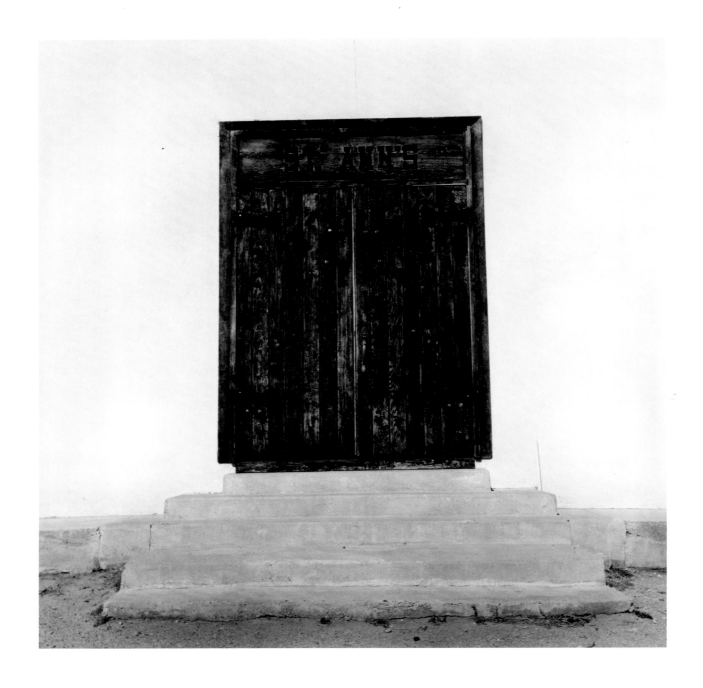

39. Doug Rhinehart, *St. Ann's Door*, 1979

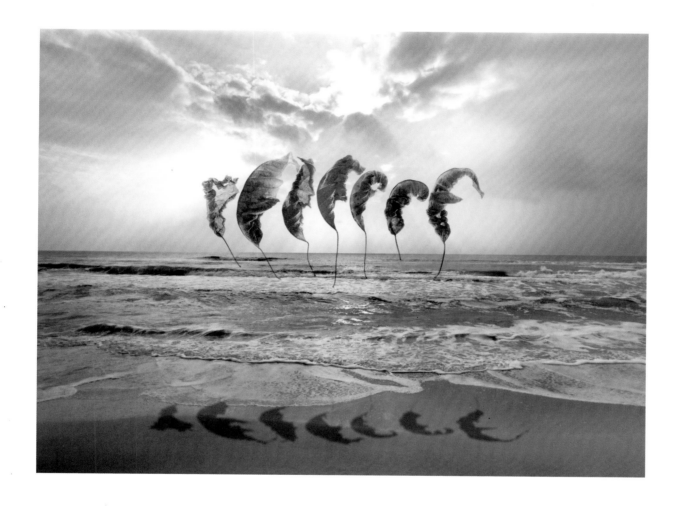

40. Jerry Uelsmann, *Untitled*, 1988

Documents of Life Although not large in number, these images of social significance are essential to an appreciation of the underlying humanist dimension to the Glickman collection. The Great Depression, the civil rights movement, global poverty, and the Holocaust are documented here.

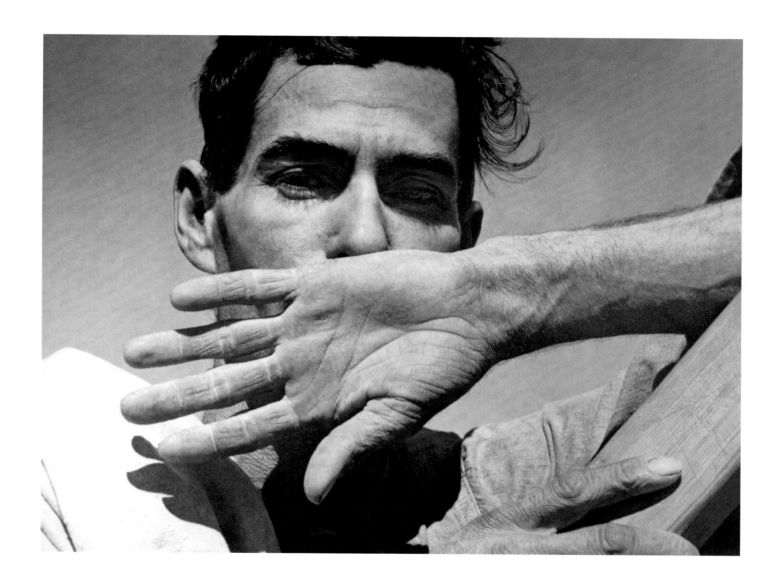

41. Dorothea Lange, *Migratory Cotton Picker, Eloy, Arizona,* 1940

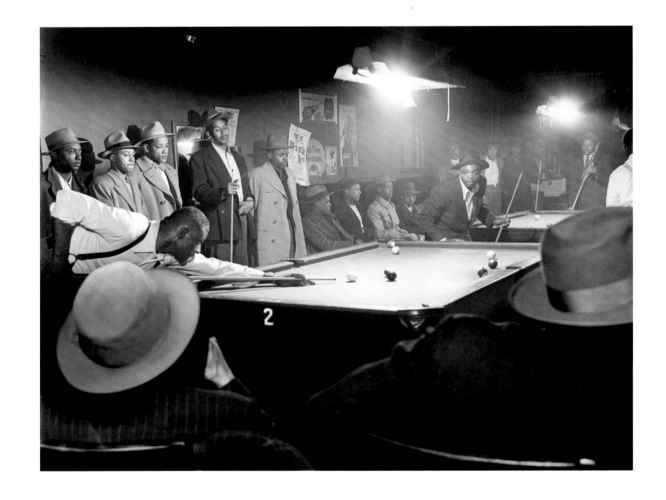

42. Wayne Miller, *Afternoon Game at Table 2*, 1948

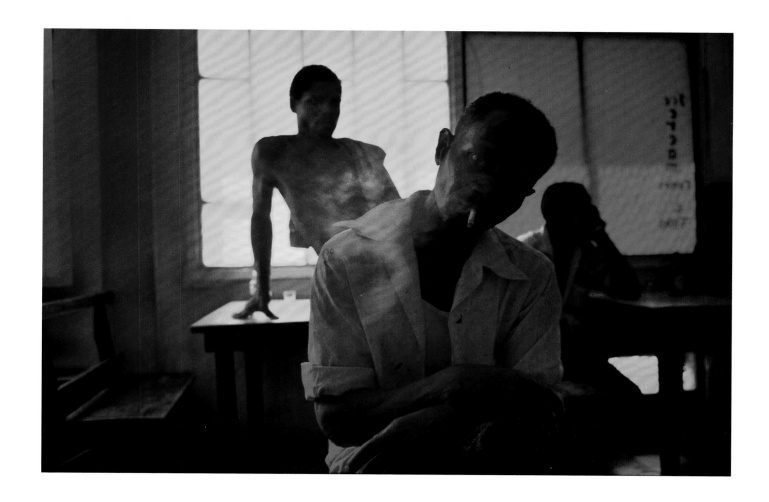

43. Alex Webb, *Grenada*, 1979

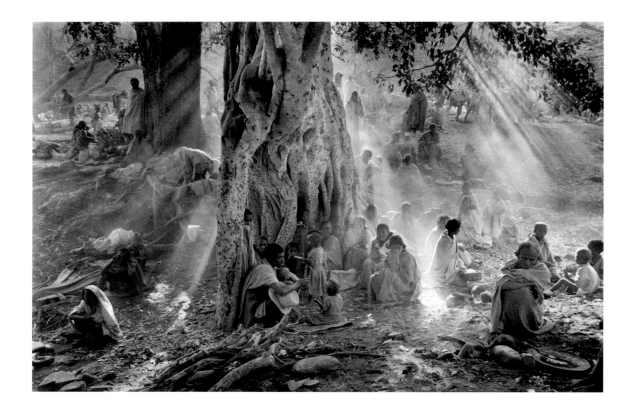

44. Sebastião Salgado, *Tigre, Ethiopia,* 1985

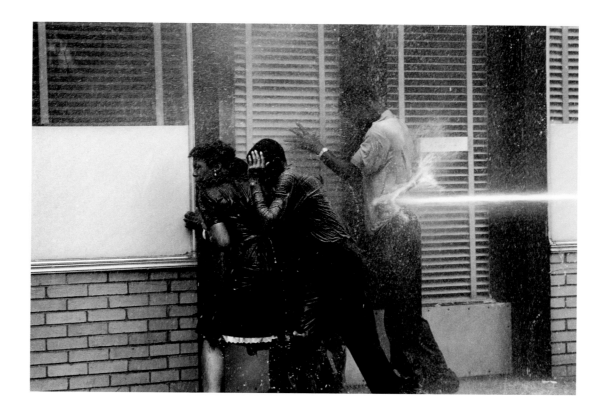

45. Charles Moore, *Birmingham Riots*, 1963

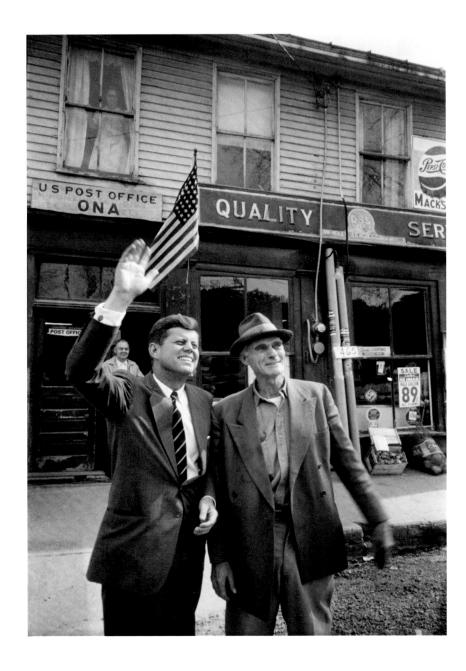

46. Jacques Lowe, *John F. Kennedy and the Local Postmaster, Ona, West Virginia*, 1960

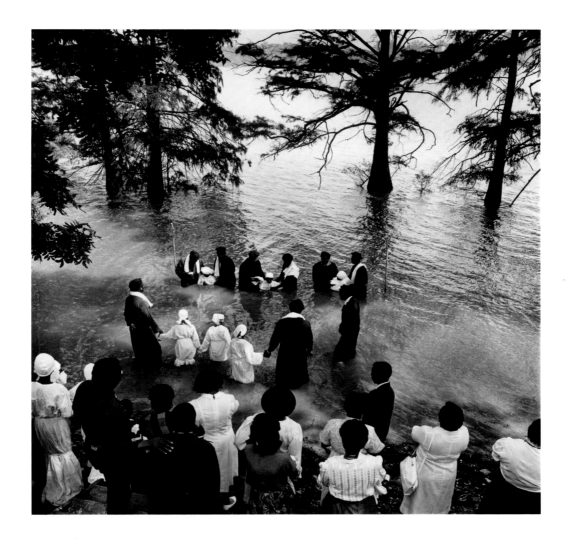

47. **Ken Light**, *River Baptism, Moon Lake, Coahoma County, Mississippi, 1989*

The Ties That Bind: Kids, Animals, and Hats Judy Glickman's own family, filled with children and grandchildren and bound by a strong faith, has always been a source of inspiration in her work as a photographer and as a collector. Humor and religion, two of the sustaining elements of human life, characterize these images of children taken around the world, of animals posed in the oddest places, and of hats worn by all types of people.

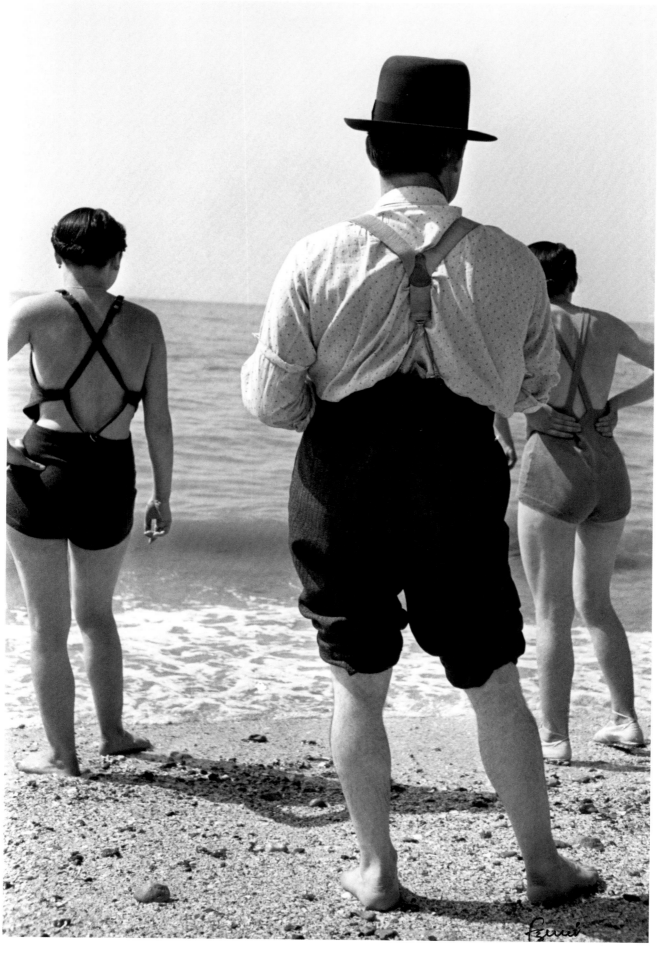

48. **Ferenc Berko,** *French Family at the Seaside. Trouville, France,* 1937

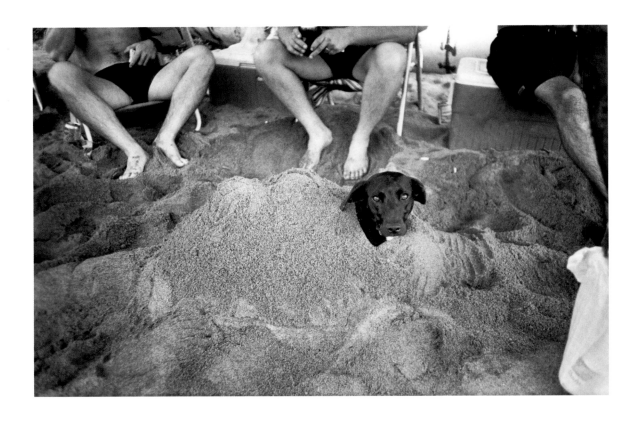

49. Melonie Bennett, *Abby as a Camel*, 1996

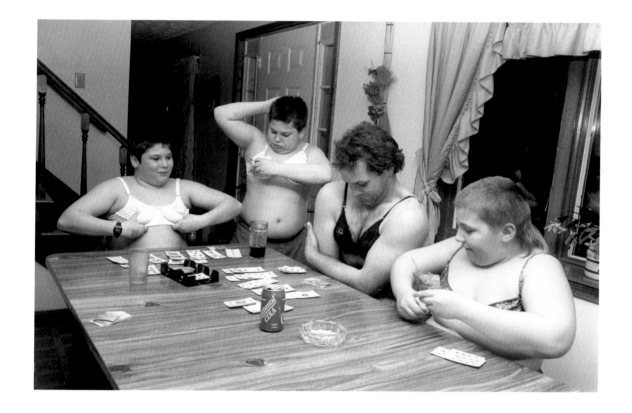

50. Melonie Bennett, *The Boys Experiencing What It Would Be Like To Have Cleavage*, 1993

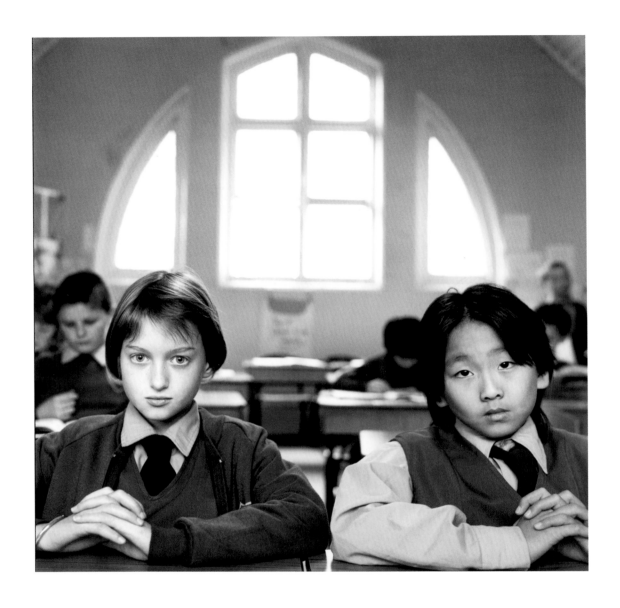

51. Mary Ellen Mark, *Australia*, 1987

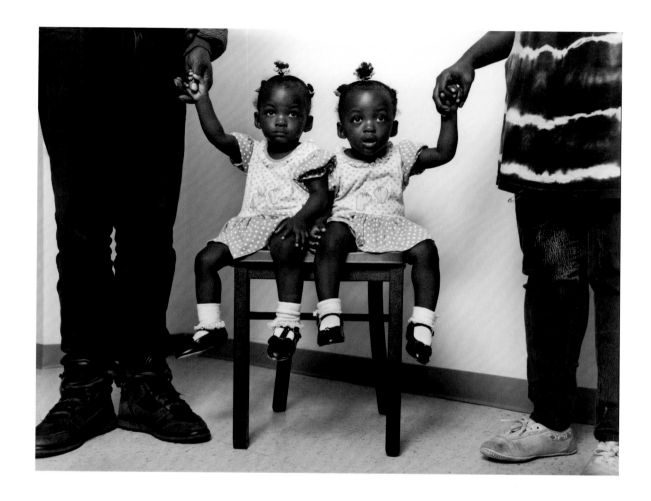

52. **Mary Ellen Mark,** *Vashira and Tashira Hargrove, Twins—H.E.L.P. Shelter, Suffolk, New York,* 1993

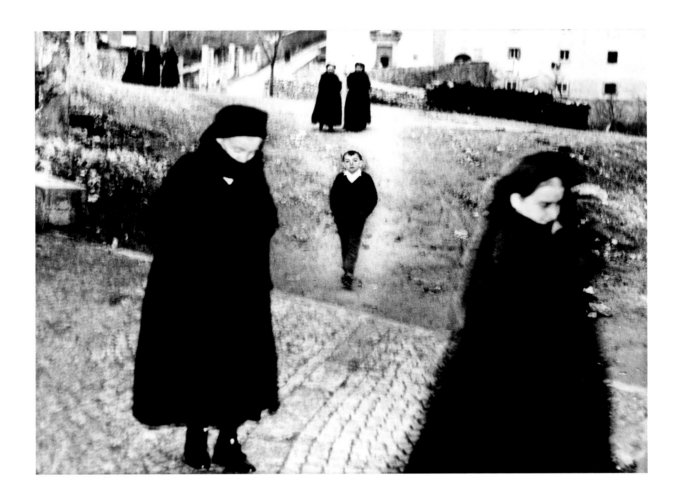

53. Mario Giacomelli, *La Gente del Sud (People of the South): Scanno,* 1962

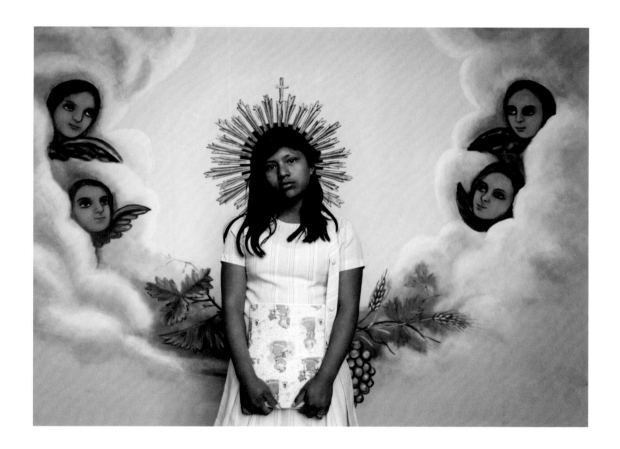

54. **Flor Garduño,** *Virgen de los Angeles (Virgin of the Angels), Tuxtla, Guerrero, 1987*

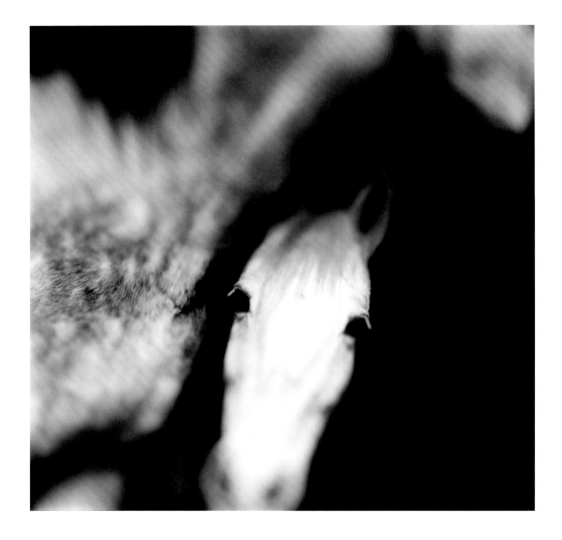

55. Keith Carter, *Bella*, 1998

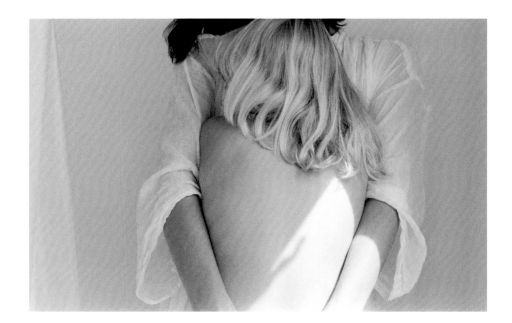

56. Kate Carter, *Untitled*, undated

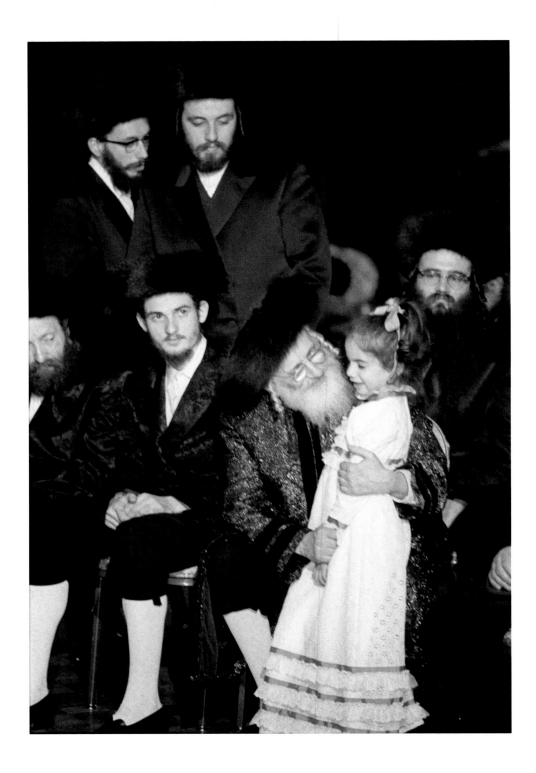

57. **Bill Aron,** *Bobover Rebbe and Granddaughter,* 1975

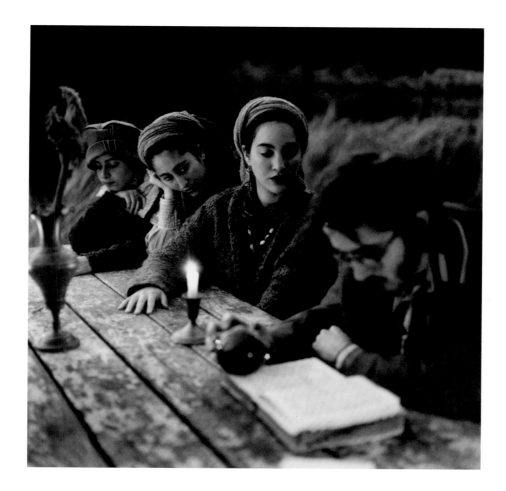

58. Jessica Shokrian, *In the Back of Beyond*, 1999

80

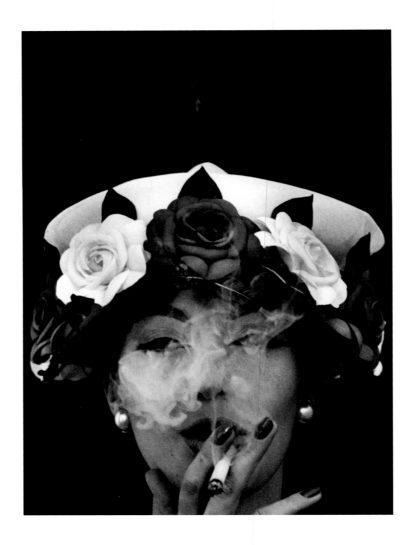

59. William Klein, *Hat + Five Roses, Paris,* 1956

60. **Verner Reed,** *DAR, Newbury, Vermont,* 1953

61. Sally Mann, *Untitled*, 1987

62. Denise Froehlich, *Family Portrait*, 2007

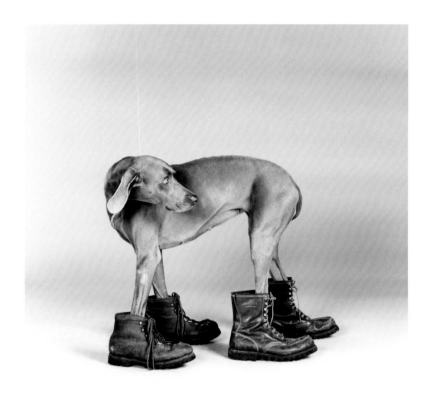

63. William Wegman, *Untitled*, 1988

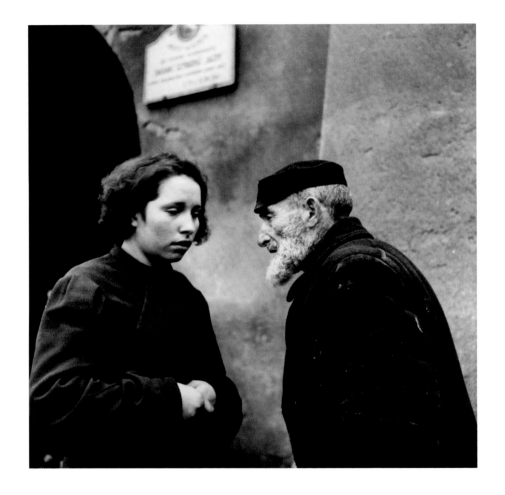

64. **Roman Vishniac,** *Granddaughter and Grandfather, Lublin,* 1938

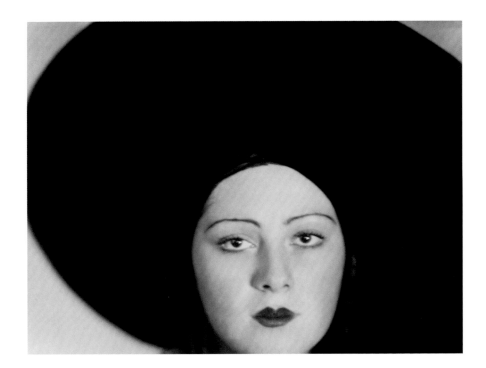

65. **Lotte Jacobi**, *Head of a Dancer* [Niura Norskaya], circa 1929

66. **Tonee Harbert**, *The Vice President, Portland*, 1990

67. Inge Morath, *Encounter on Times Square*, 1957

Seeing Stars: Artists and Actors Having lived much of her life California, Judy Glickman could not avoid the impact of Hollywood and the American taste for celebrity. These photographs acknowledge our passion for the stars of the art world and the silver screen, as well as the myriad ways in which photographers have captured the essence of fame. Some are about outward glamour and beauty, while others examine introspection and self-discovery.

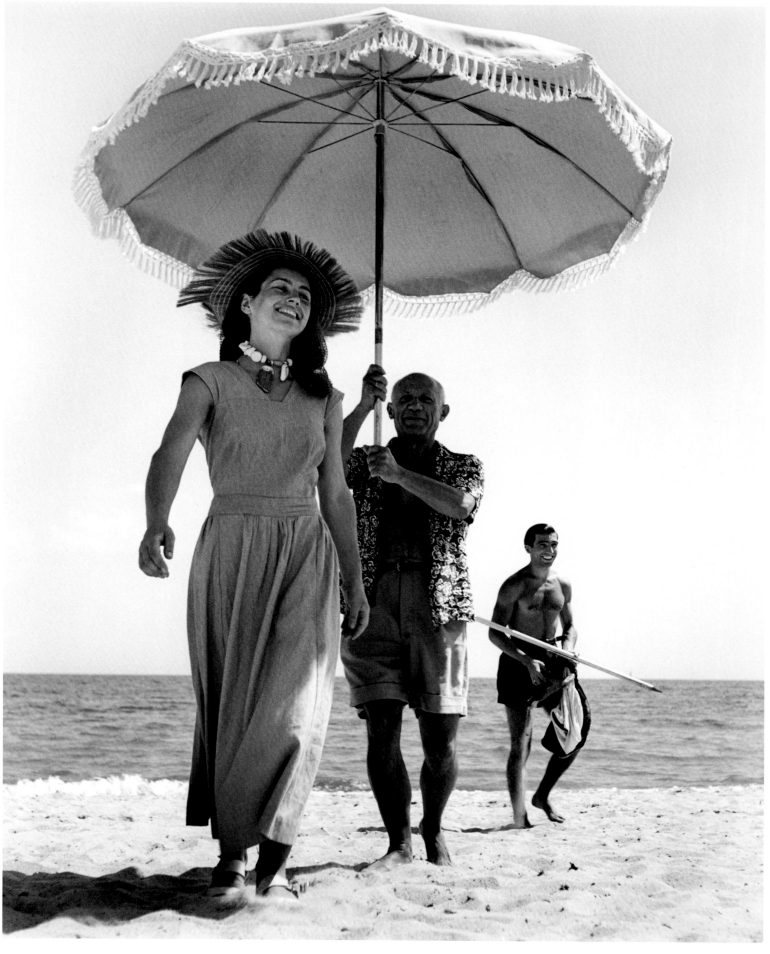

68. Robert Capa, *Pablo Picasso and Françoise Gilot*, 1948

92

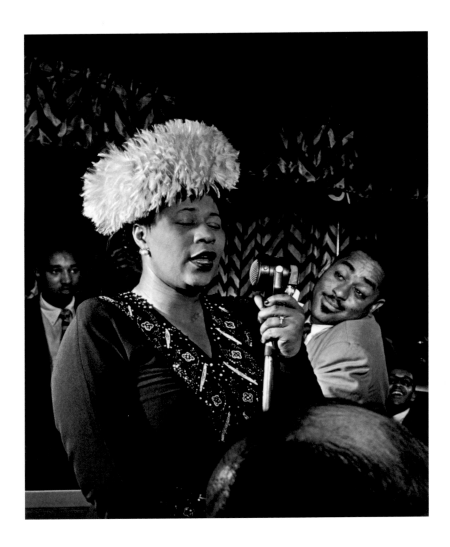

69. William Gottlieb, *Ella Fitzgerald, Dizzy Gillespie with Ray Brown and Milt Jackson, 1947*

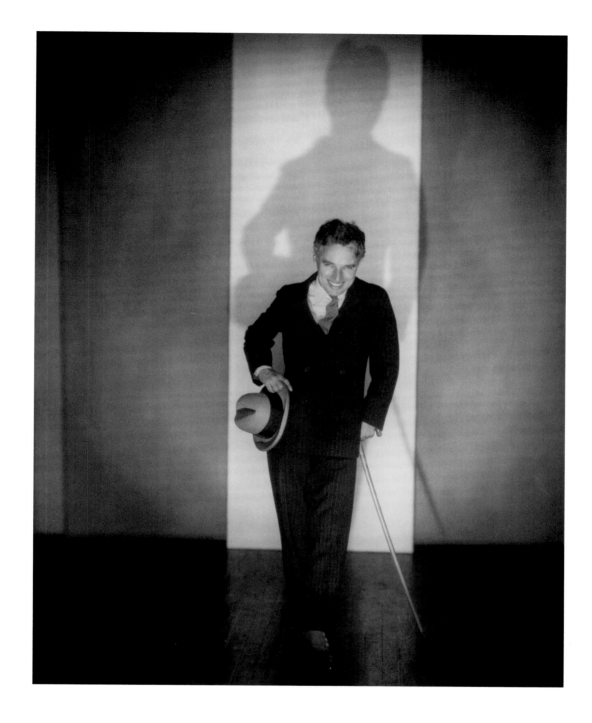

70. Edward Steichen, *Charlie Chaplin, New York,* 1925

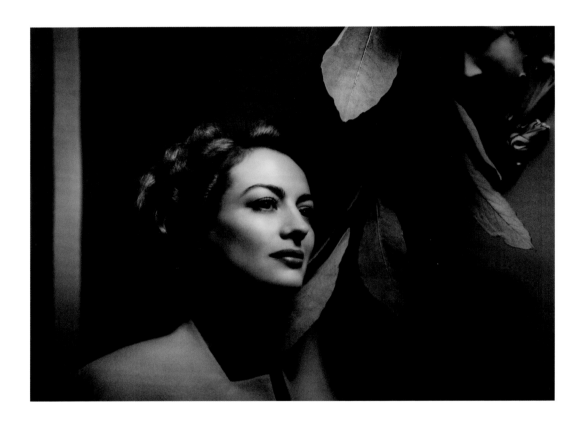

71. George Hurrell, *Joan Crawford*, 1932

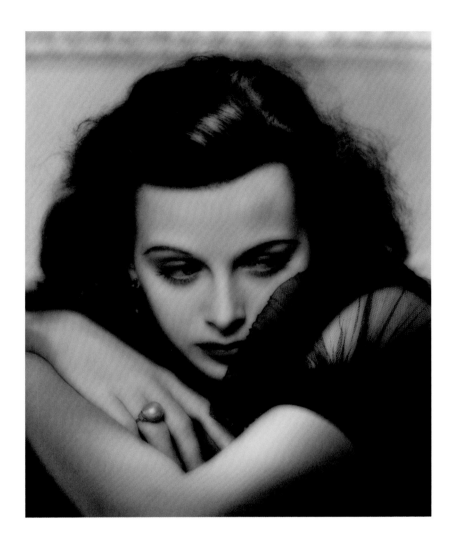

72. George Hurrell, *Hedy Lamarr,* 1938

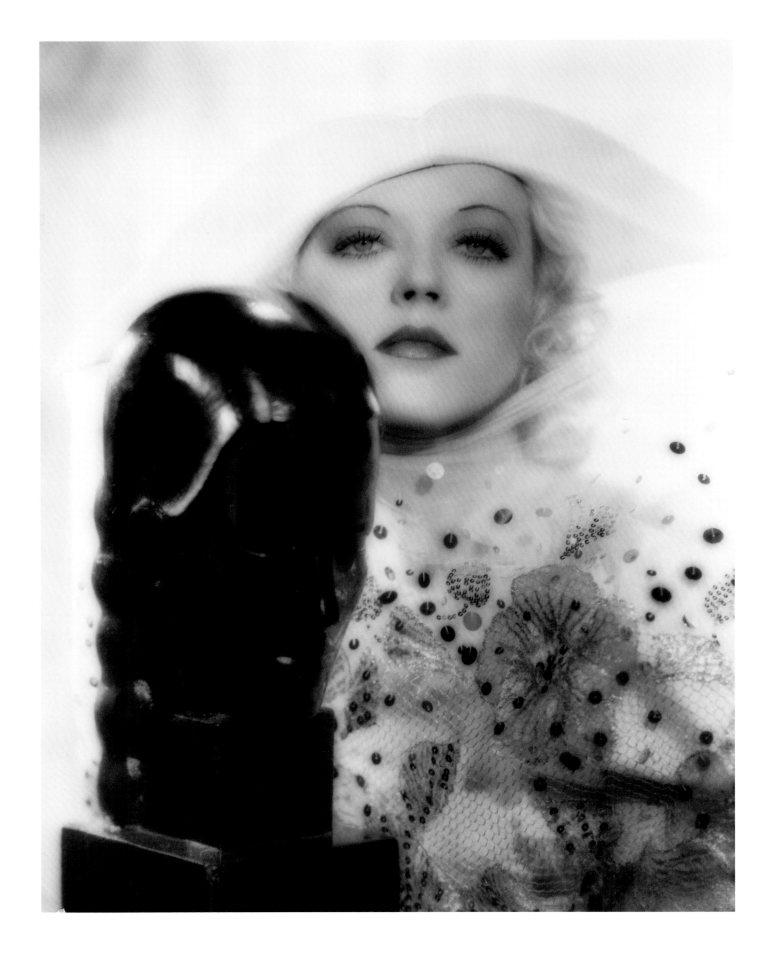

73. **Elmer Fryer,** *Marion Davies,* circa 1930

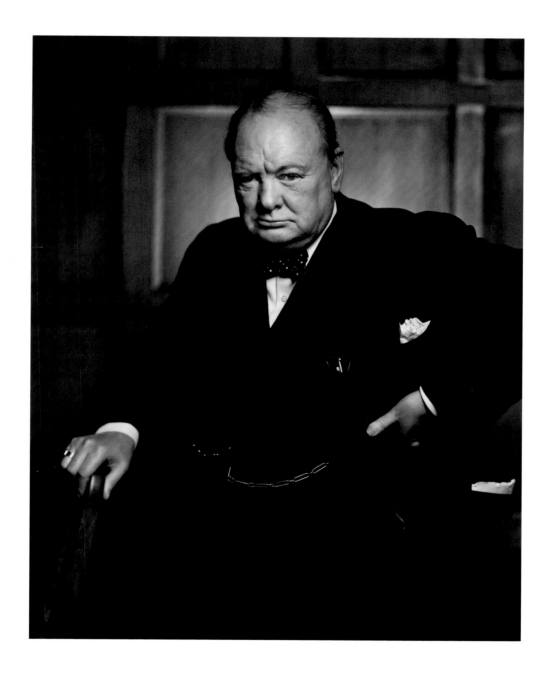

74. **Yousuf Karsh,** *Winston Churchill,* 1941

75. **Arnold Newman,** *Mary Ellen Mark, Rockport, Maine,* 1993

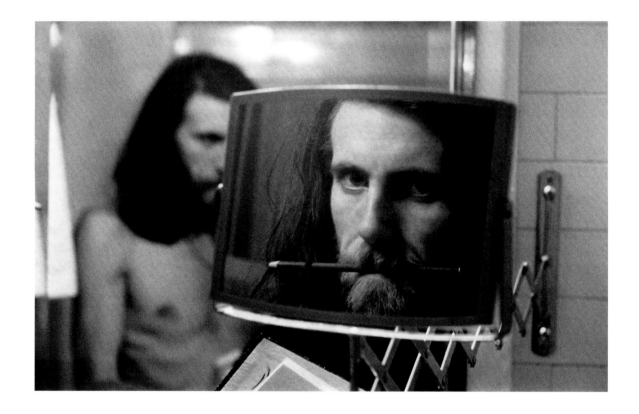

76. **Graham Nash,** *Self-Portrait in the Plaza,* 1974

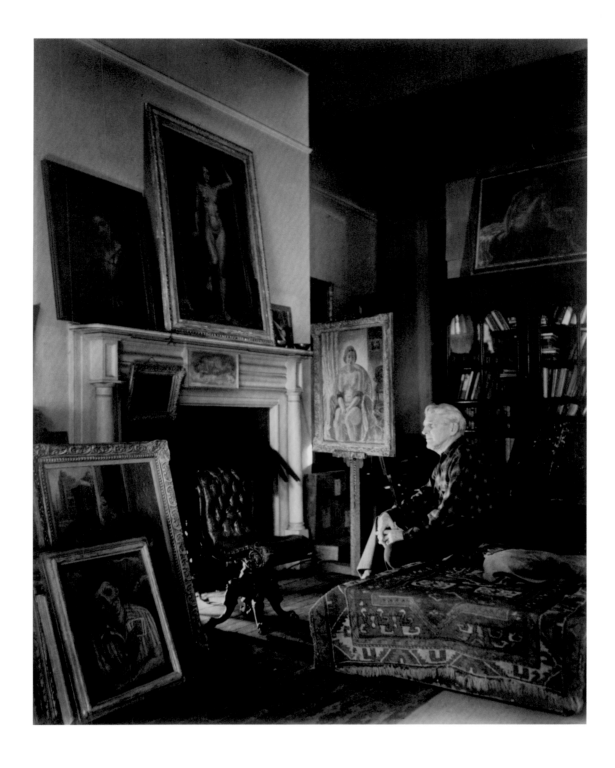

77. **Berenice Abbott,** *John Sloan, Greenwich Village, New York,* late 1940s

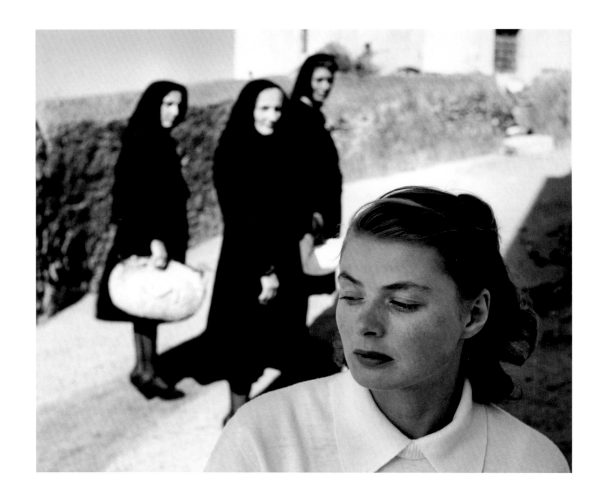

78. Gordon Parks, *Ingrid Bergman at Stromboli*, 1949

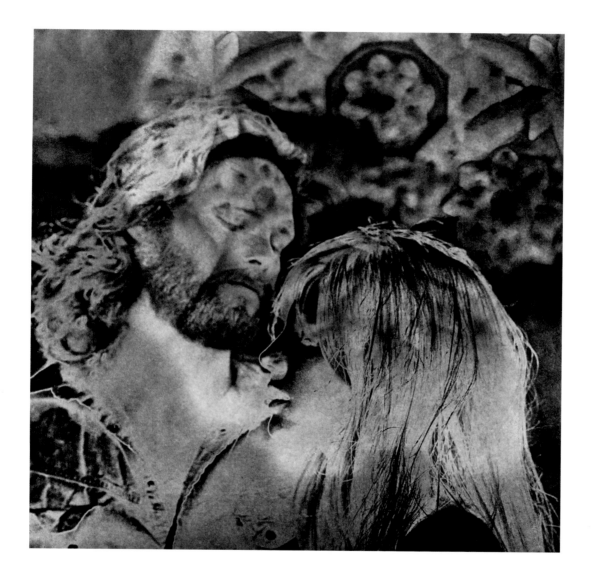

79. Edmund Teske, *Jim Morrison and Pam*, 1969

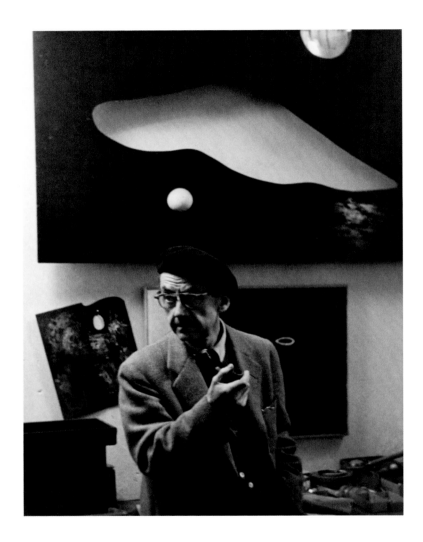

80. **Todd Webb**, *Man Ray*, 1951

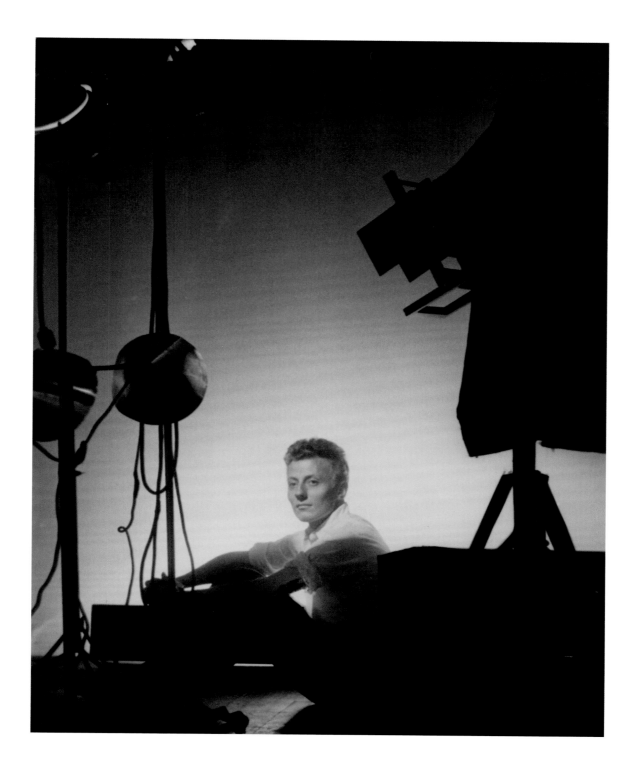

81. George Daniell, *Self-Portrait*, 1939

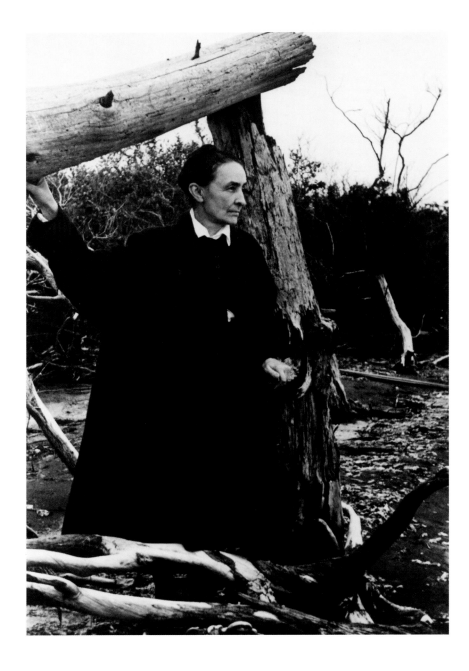

82. **George Daniell,** *Georgia O'Keeffe on Fire Island, New York,* 1941

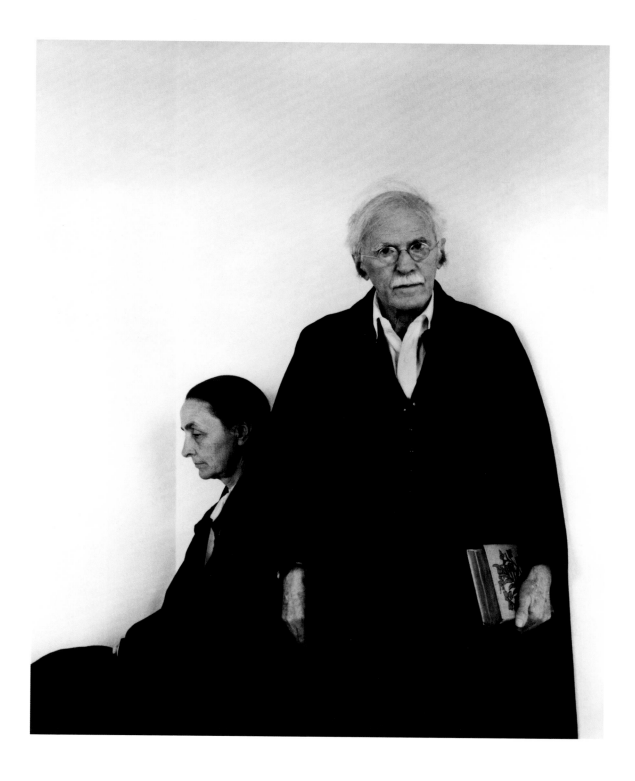

83. **Arnold Newman**, *Alfred Stieglitz and Georgia O'Keeffe, An American Place*, 1944

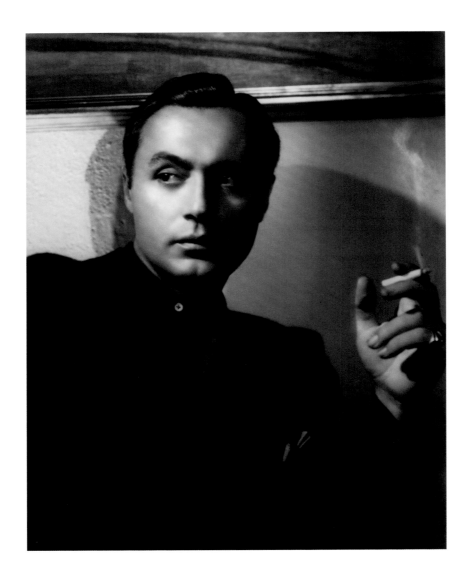

84. George Hurrell, *Charles Boyer*, 1938

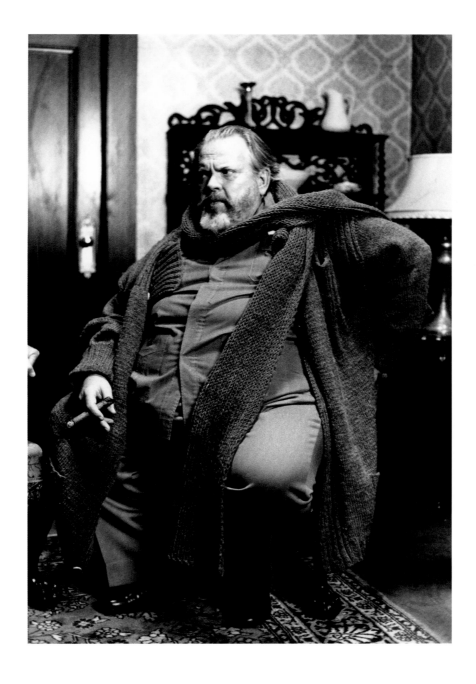

85. Timothy Greenfield-Sanders, *Orson Welles*, 1979

86. Barbara Goodbody, *Che*, 2003

87. Arnold Newman, *Allen Ginsberg,* 1985

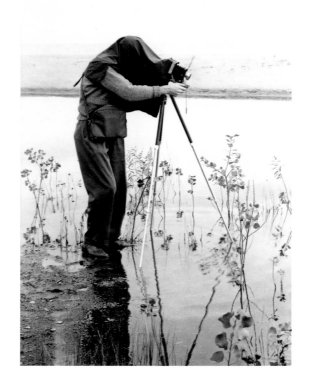

88. **Todd Webb,** *Harry Callahan,* 1941

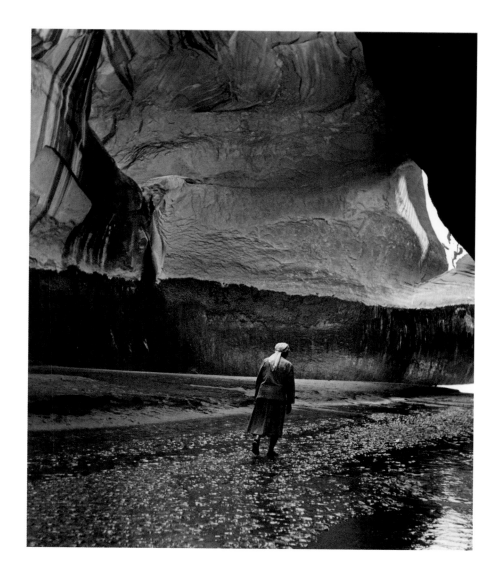

89. **Todd Webb,** *Georgia O'Keeffe, Twilight Canyon, Lake Powell, Utah,* 1964

The Human Body: Still and In Motion The sensual beauty of the body, both male and female, has always been a traditional subject for artists and photographers. Images of the body in the Glickman collection sometimes place that examination of human form in a wider contemporary social context dealing with the issues of voyeurism, sexual relations, and a highly charged sense of romanticism.

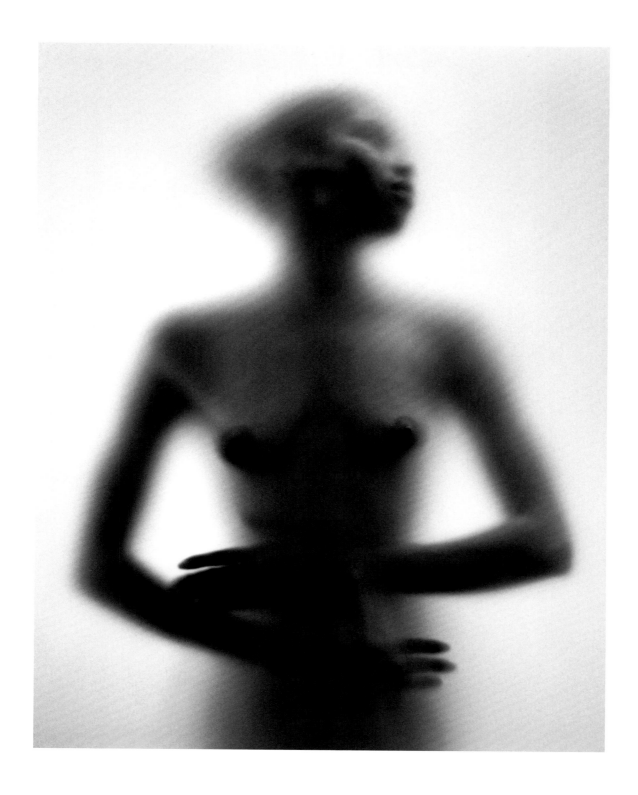

90. Ruth Bernhard, *Veiled Black*, 1974

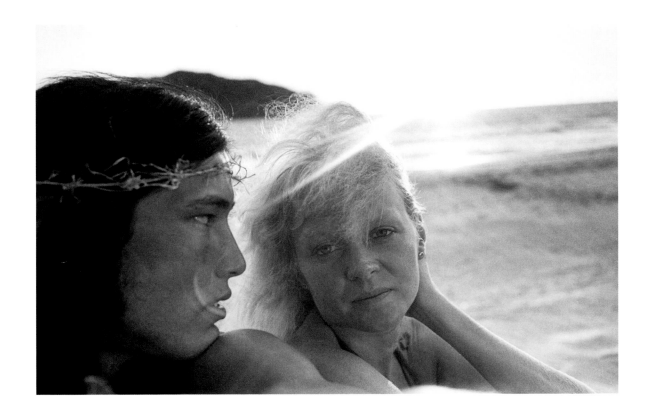

91. Cheri Hiser, *First Days in Mexico, Self Portrait,* 1971

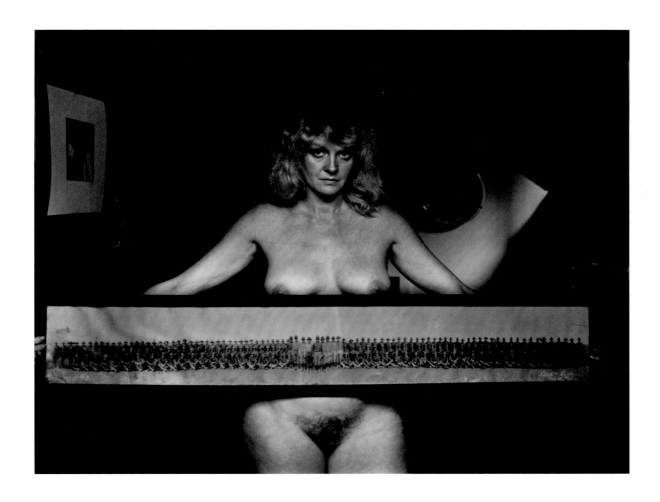

92. Judy Dater, *Cherie*, 1972

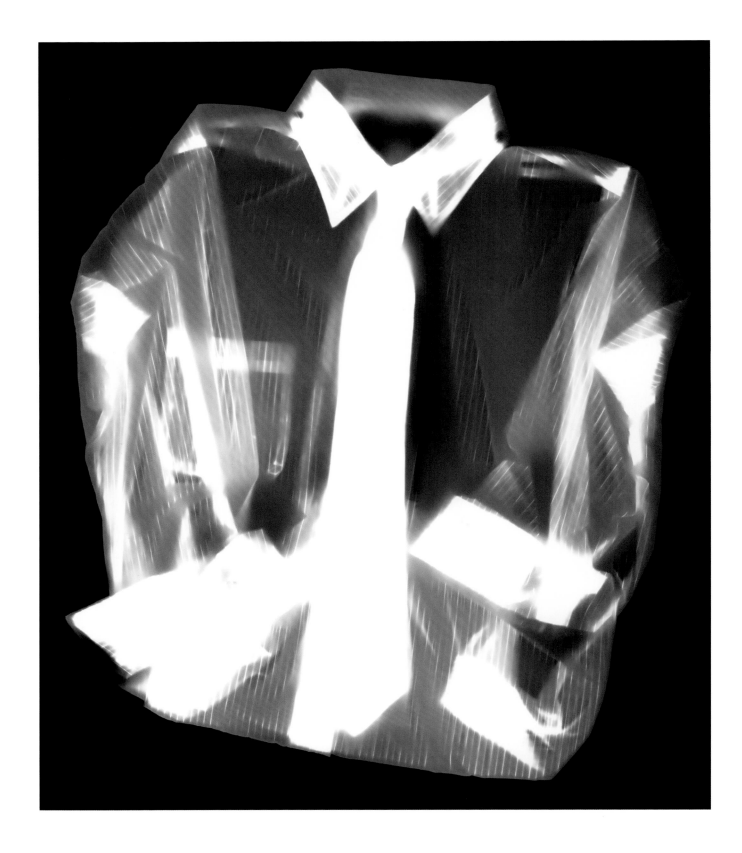

93. **Hilary French,** *Indexical Hierarchy/Elusive Object (part a),* 1989

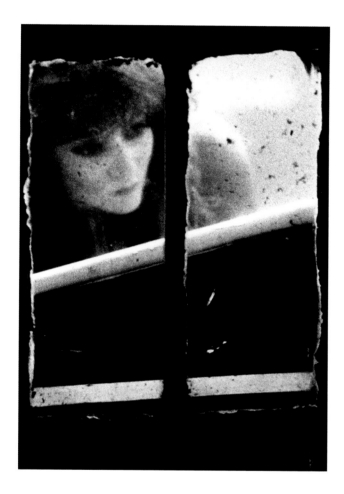 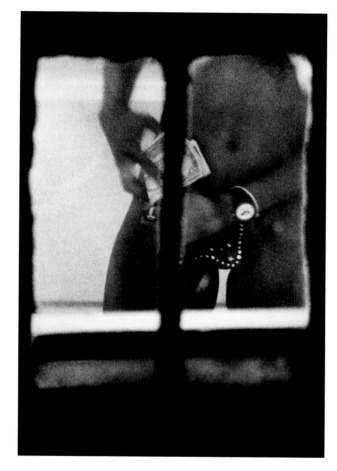

94. **Merry Alpern,** *No. 19* and *No. 28* from *Window Series*, 1994

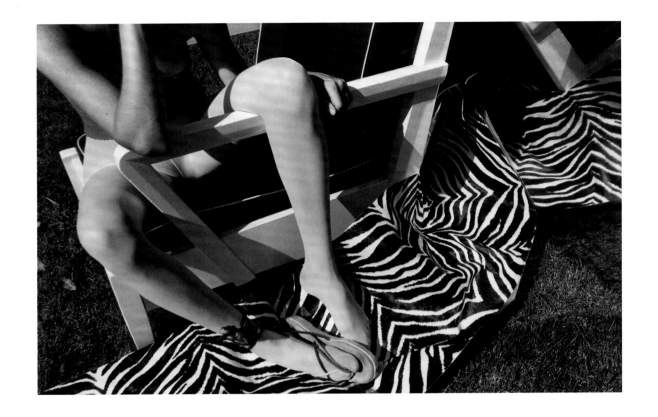

95. Kenda North, *Patty*, 1985

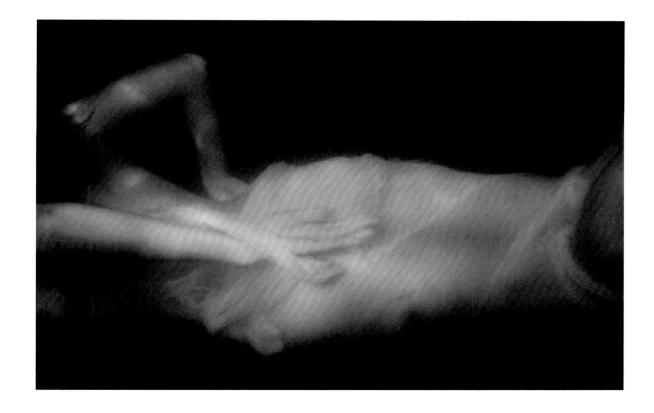

96. Nanci Kahn, *Brettun's Pond*, 1986

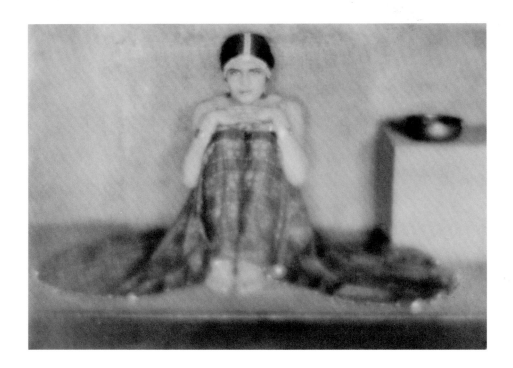

97. Jane Reece, *Have Drowned My Glory in a Shallow Cup*, 1919

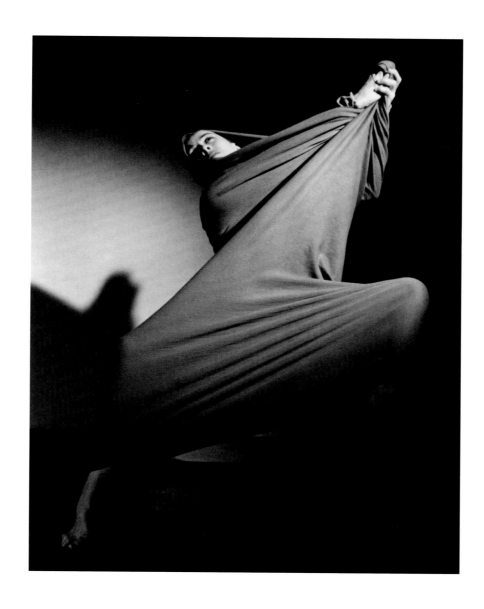

98. Barbara Morgan, *Martha Graham, Lamentation (Oblique)*, 1935

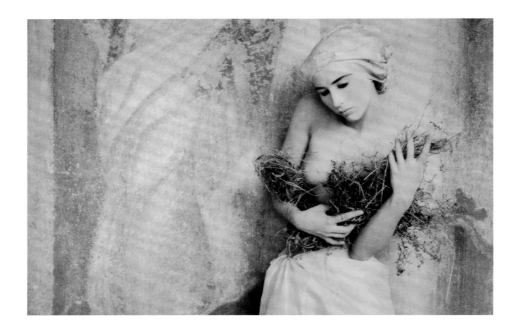

99. Joyce Tenneson, *Italy*, 1984

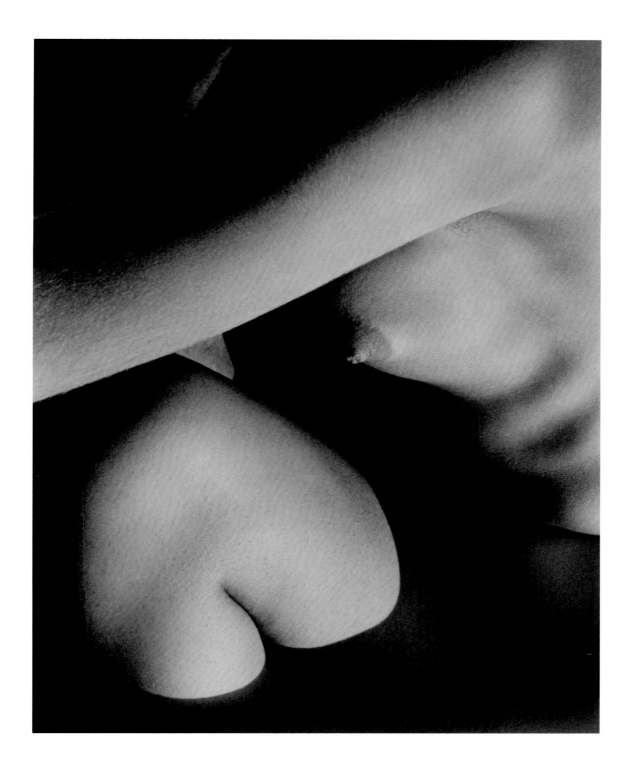

100. Ruth Bernhard, *Triangles*, 1946

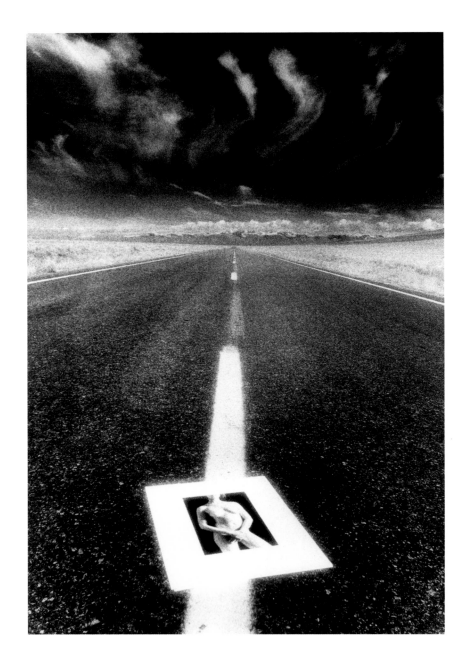

101. Doug Rhinehart, *Journey,* 1984

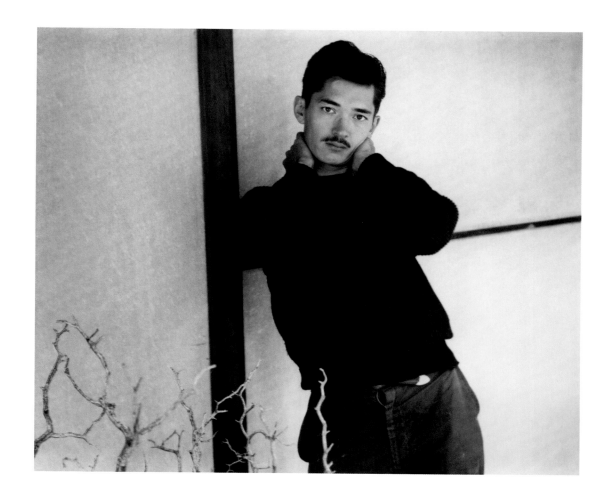

102. **Minor White,** *Bill LaRue at Brett Weston's House, Carmel Highlands, California,* 1959

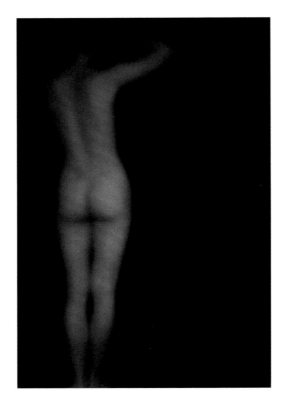

103. Marilyn Ruseckas, *April 11, #1*, 1980

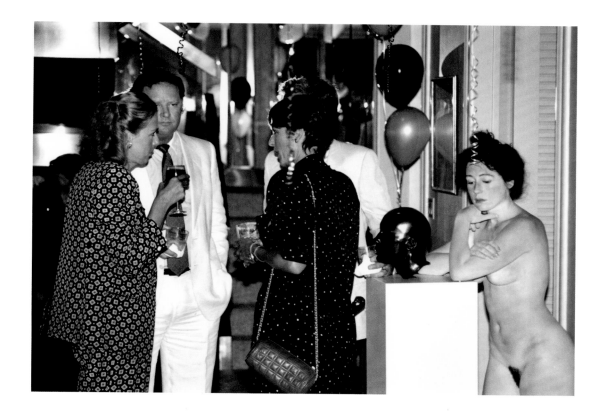

104. Jessica Shokrian, *Untitled*, 1985

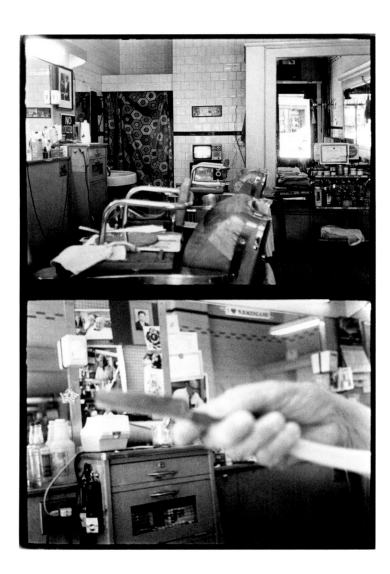

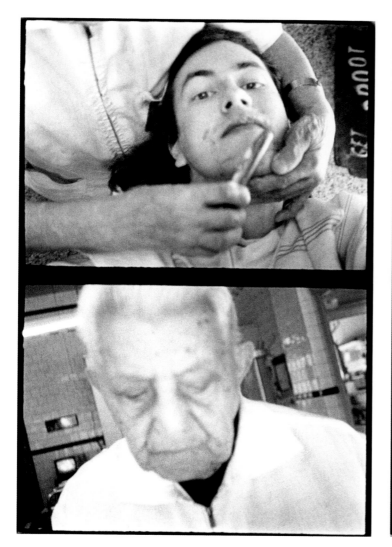
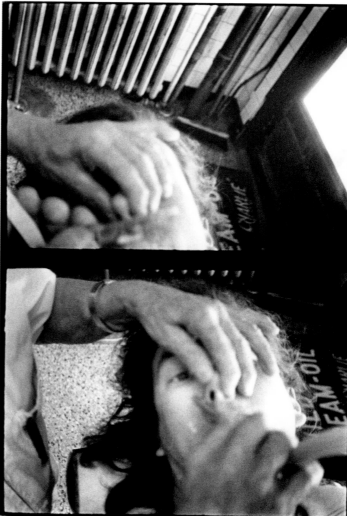

105. Peter Shellenberger, *Danny, Myself, and the Shave*, 1994

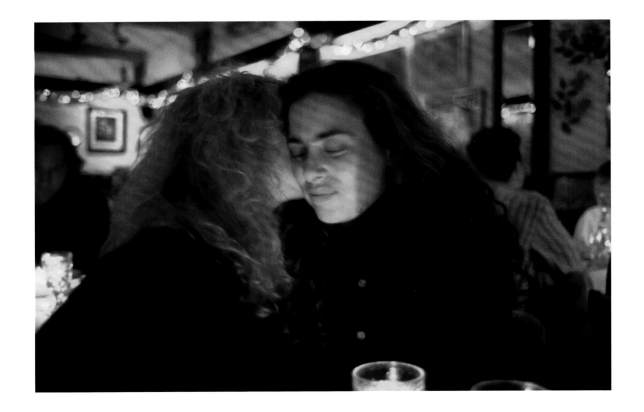

106. **Nan Goldin,** *Lynette and Donna at Marion's Restaurant, NYC,* 1991

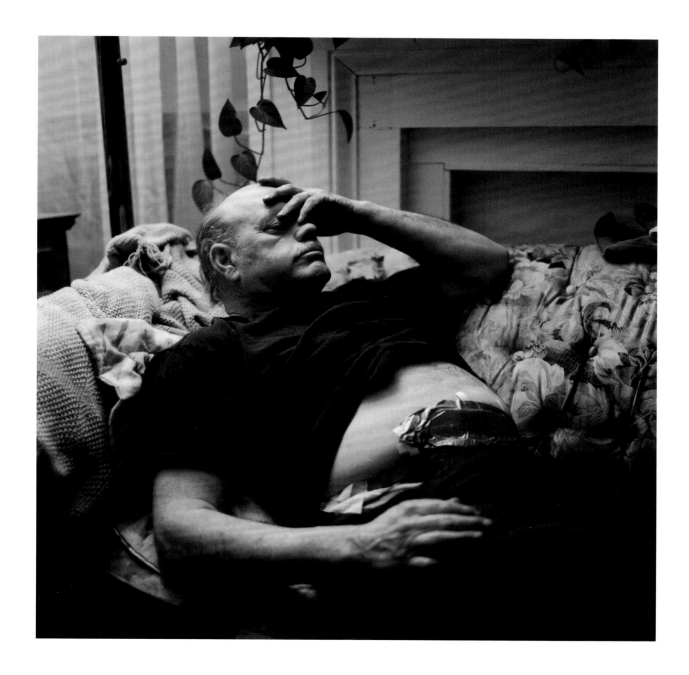

107. Melonie Bennett, *Duct Tape Hernia Belt*, 2000

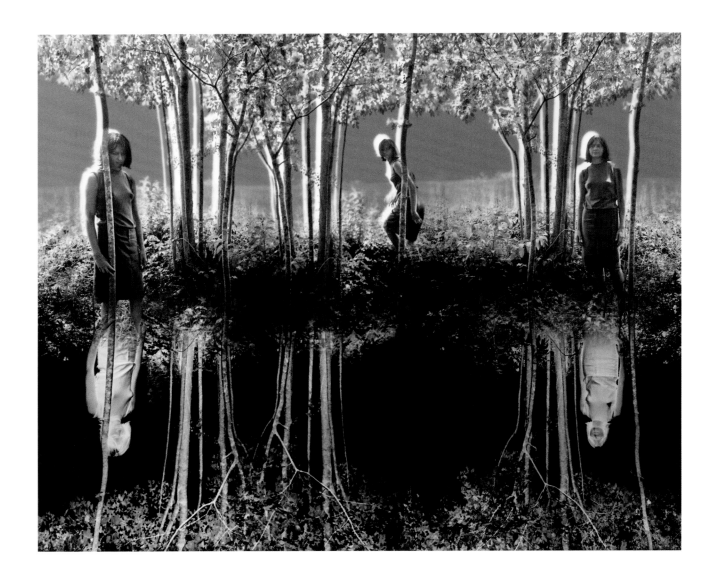

108. Jerry Uelsmann, *Small Woods Where I Met Myself*, 1967

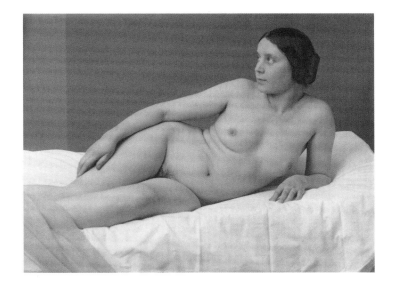

109. Paul Outerbridge, Jr., *Reclining Nude*, 1923

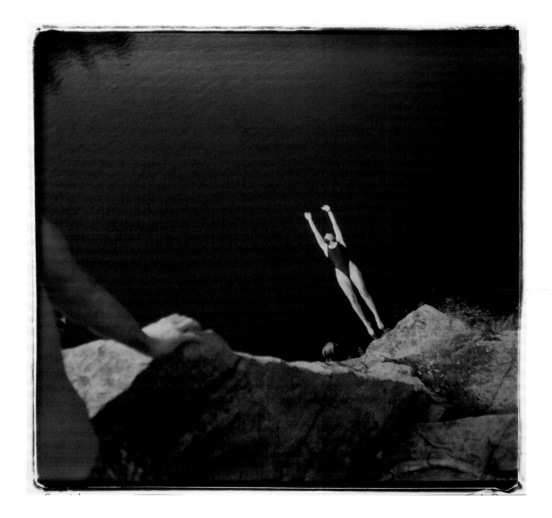

110. Jay York, *Danya at the Quarry*, 1993

Exhibition Checklist

This checklist is organized alphabetically by artist. Dates following the titles are for both negative and print unless otherwise indicated. Dimensions in inches represent the image size and are listed with height preceding width. Plate numbers appear in [] at the end of the entry.

Berenice Abbott (United States, 1898–1991)
John Sloan, Greenwich Village, New York, late 1940s
Gelatin silver print, 13⁹/₁₆ x 8 [77]

Merry Alpern (United States, born 1955)
No. 19 from *Window Series*, 1994
Gelatin silver print, 19¾ x 15¹⁵/₁₆ [94 left]

Merry Alpern (United States, born 1955)
No. 28 from *Window Series*, 1994
Gelatin silver print, 19¾ x 15¹⁵/₁₆ [94 right]

Bill Aron (United States, born 1939)
Bobover Rebbe and Granddaughter, 1975
Gelatin silver print, 16 x 10⅞ [57]

Melonie Bennett (United States, born 1969)
Menomania, 1991
Chromogenic print, 9½ x 15⅞

Melonie Bennett (United States, born 1969)
The Boys Experiencing What It Would Be Like To Have Cleavage, 1993
Gelatin silver print, 13¼ x 19½ [50]

Melonie Bennett (United States, born 1969)
Abby as a Camel, 1996
Gelatin silver print, 16 x 20 [49]

Melonie Bennett (United States, born 1969)
Boomer with Drunk Girl, 1996
Gelatin silver print, 15¹⁵/₁₆ x 19⅞

Melonie Bennett (United States, born 1969)
Duct Tape Hernia Belt, 2000
Chromogenic print, 14¼ x 14¼ [107]

Ferenc Berko (United States, born Hungary, 1916–2000)
French Family at the Seaside. Trouville, France, 1937
Gelatin silver print, 13¾ x 8, printed 1981 [48]

Ruth Bernhard (United States, born 1905)
Triangles, 1946
Gelatin silver print, 9½ x 7½, printed 1991 [100]

Ruth Bernhard (United States, born 1905)
Veiled Black, 1974
Gelatin silver print, 10 x 8 [90]

Margaret Bourke-White (United States, 1904–1971)
United States Airship Akron, 1931
Gelatin silver print, 20½ x 25¹⁵/₁₆ [2]

Bill Brandt (England, 1904–1983)
Maid Serving Tea, London, 1939
Gelatin silver print, 8¹⁵/₁₆ x 7⅝

Robert Capa (United States, born Hungary, 1913–1954)
Pablo Picasso and Françoise Gilot, 1948
Gelatin silver print, 11⅜ x 14⁷/₁₆, printed later [68]

Paul Caponigro (United States, born 1932)
Reflecting Stream, Redding, Connecticut, 1968
Gelatin silver print mounted on board, 9⅞ x 13½ [18]

Paul Caponigro (United States, born 1932)
Untitled, 1967–72, from *Stonehenge Portfolio*, 1978
Gelatin silver print, 9½ x 11½

Paul Caponigro (United States, born 1932)
Untitled, 1967–72, from *Stonehenge Portfolio*, 1978
Gelatin silver print, 9¾ x 13½ [19]

Kate Carter (United States, 1946–1984)
Untitled, undated
Gelatin silver print, 6 x 9 [56]

Keith Carter (United States, born 1948)
Bella, 1998
Toned gelatin silver print. 15¼ x 15¼ [55]

Linda Connor (United States, born 1944)
Monk's Residence, Zanskar, India, 1985
Gelatin silver print, 7⅞ x 9¾ [20]

Imogen Cunningham (United States, 1883–1976)
Magnolia Blossom, 1925
Gelatin silver print mounted on board, 10½ x 13¼, printed 1970s [5]

Edward Sheriff Curtis (United States, 1868–1952)
The Fisherman, Wisham, 1904
Orotone, 14 x 10¹⁵/₁₆ [Page 7]

George Daniell (United States, 1911–2002)
Self-Portrait, 1939
Gelatin silver print, 10 x 7⅞ [81]

George Daniell (United States, 1911–2002)
Georgia O'Keeffe on Fire Island, New York, 1941
Gelatin silver print, 11⅝ x 7⅞ [82]

George Daniell (United States, 1911–2002)
John Marin, Cape Split, Maine, 1952
Gelatin silver print, 11 x 9⅞ [Page 143]

George Daniell (United States, 1911–2002)
Untitled [Grand Central Station, N.Y.], undated
Gelatin silver print, 13 x 8½ [21]

Judy Dater (United States, born 1941)
Cherie, 1972
Gelatin silver print mounted on board, 10 x 12⅞ [92]

Robert Dawson (United States, born 1950)
Delta Farm, Sacramento River, 1984
Gelatin silver print, 9½ x 12½ [22]

Irving Bennett Ellis (United States, 1902–1977)
Puzzles, 1929
Gelatin silver print, 8 x 6⅞ [15]

Irving Bennett Ellis (United States, 1902–1977)
Art in Sunlight, 1930
Gelatin silver print, 9⅝ x 7⅞ [13]

Irving Bennett Ellis (United States, 1902–1977)
Washing Their Nets at Fisherman's Wharf, 1932
Gelatin silver print, 16¾ x 13½ [14]

Irving Bennett Ellis (United States, 1902–1977)
X-rays, circa 1933
Gelatin silver print, 13⅜ x 10½ [17]

Irving Bennett Ellis (United States, 1902–1977)
Untitled [Louise Weinberg Ellis], circa 1936
Gelatin silver print from a composite negative, 9 x 6⅞ [16]

Irving Bennett Ellis (United States, 1902–1977)
Siesta, 1942
Gelatin silver print, 13 x 10¼ [12]

Rose-Lynn Fisher (United States, born 1955)
Woman in Passage, 1998
Carbon pigment print, 9 x 13, printed 2006 [25]

Sharon Fox (United States, 1946)
Vinalhaven Ferry, Rockland, Maine, 1979
Infrared gelatin silver print, 10¼ x 15 [37]

Vida Freeman (United States, born 1937)
Nether Largie South, Kilmarten Valley Scotland, 1984
Platinum print on wove paper, 4 x 4

Hilary French, (United States, born 1957)
Indexical Hierarchy/Elusive Object, 1989
Photogram (A), Cast Hydrocal with graphite (B), Koda-lith transparency (C), gelatin silver print (D)
26½ x 22½ (each) [93 part A]

Denise Froehlich (United States, born 1967)
Family Portrait, 2007
Split sepia-toned gelatin silver print, 17 x 17¼ [62]

Elmer Fryer (United States, 1898–1944)
Marion Davies, circa 1930
Gelatin silver print mounted on board, 13⅜ x 10½ [73]

Flor Garduño (Mexico, born 1957)
Virgen de los Angeles (Virgin of the Angels), Tuxtla, Guerrero, 1987
Gelatin silver print, 8¹⁵/₁₆ x 11⅞ [54]

Mario Giacomelli (Italy, 1913–2000)
La Gente del Sud (People of the South): Scanno, 1962
Gelatin silver print, 11⁹/₁₆ x 15⁷/₁₆ [53]

Ralph Gibson (United States, born 1939)
New York, 1968, from *New York Portfolio I*
Mother Jones 1998 Fine Print Portfolio
Gelatin silver print, 9 x 6¹/₁₆ [33]

Nan Goldin (United States, born 1953)
Lynette and Donna at Marion's Restaurant, NYC, 1991
from *New York Portfolio I*,
Mother Jones 1998 Fine Print Portfolio
Cibachrome print, 9 x 13½ [106]

Barbara Goodbody (United States, born 1936)
Village Near Allahabad, Uttar Pradesh, India, 1998
Cibachrome print, 13½ x 9

Barbara Goodbody (United States, born 1936)
Che from the *Cuba Impression* series, 2003
Iris print, 5½ x 4 [86]

William Gottlieb (United States, 1917–2006)
Ella Fitzgerald, Dizzy Gillespie with Ray Brown and Milt Jackson, 1947
Gelatin silver print, 13 x 10⅜, printed 1979 [69]

Timothy Greenfield-Sanders (United States, 1952)
Orson Welles, 1979
Gelatin silver print, 20½ x 14¼ [85]

Tonee Harbert (United States, born 1962)
Dave "Dog Man" Koplow, 1990
Gelatin silver print, 8¾ x 13¼

Tonee Harbert (United States, born 1962)
The Vice President, Portland, 1990
Gelatin silver print, 8¾ x 13½ [66]

Cheri Hiser (United States, born 1939)
First Days in Mexico, Self-Portrait, 1971
Gelatin silver print mounted on board, 8⅞ x 13½, printed 1975 [91]

George Hurrell (United States, 1904–1992)
Greta Garbo, 1930
Gelatin silver print, 19 x 15½, printed later
[Frontispiece]

George Hurrell (United States, 1904–1992)
Joan Crawford, 1932
Gelatin silver print, 10½ x 13¾, printed 1980 [71]

George Hurrell (United States, 1904–1992)
Charles Boyer, 1938
Gelatin silver print, 13⅜ x 10½, printed 1981 [84]

George Hurrell (United States, 1904–1992)
Hedy Lamarr, 1938
Gelatin silver print, 19³⁄₁₆ x 15½, printed later [72]

Philip Isaacson (United States, born 1924)
Havelli in Mandawa, Western Rajistan, India, 1991
Cibachrome print, 6 x 8¾ [27]

Lotte Jacobi (United States, born Germany, 1896–1990)
Head of a Dancer [Niura Norskaya], circa 1929
Gelatin silver print, 7⅜ x 9½ [65]

Nanci Kahn (United States, born 1959)
Brettun's Pond from *Underwater Series No. 1*, 1986
Cibachrome, 18 x 12 [96]

Yousuf Karsh (Canada, born Armenia, 1908–2002)
Winston Churchill, 1941
Gelatin silver print, 9½ x 7⅛, printed later [74]

Michael Kenna (United States, born 1953)
Angelus, Vezelay, Burgundy, France, 1993
Toned gelatin silver print, 7⁹⁄₁₆ x 7¾ [30]

Michael Kenna (United States, born 1953)
Wave, Scarborough, Yorkshire, England, 1981
Gelatin silver print, 6 x 9⅛ [31]

William Klein (United States, born 1928)
Hat + Five Roses, Paris, 1956
Gelatin silver print mounted on board, 17 x 13, printed later [59]

Dorothea Lange (United States, 1895–1965)
Migrant Mother, Nipomo, California, 1936
Gelatin silver print mounted on board, 13¼ x 10⅛, printed by Arthur Rothstein, 1970s [8]

Dorothea Lange (United States, 1895–1965)
Migratory Cotton Picker, Eloy, Arizona, 1940
from *Founders and Friends, Aperture at 50 Portfolio*
Platinum palladium print, 7¼ x 9⅜, printed by Sal Lopes, 2002 [41]

Francis Orville Libby (United States, 1883–1961)
Nocturne—Pathway of the Moon, 1917
Gum bichromate print, 13¼ x 9⅞ [32]

Ken Light (United States, born 1951)
River Baptism, Moon Lake, Coahoma County, Mississippi, from the *Delta Time* series,1989
Gelatin silver print, 8⁷⁄₁₆ x 8½ [47]

Jacques Lowe (United States, born Germany, 1930–2001)
John F. Kennedy and the Local Postmaster, Ona, West Virginia, 1960
Gelatin silver print, 11⅞ x 8 [46]

Sally Mann (United States, born 1951)
Untitled, 1987
Gelatin silver print, 9¾ x 7¾ [61]

Mary Ellen Mark (United States, 1940)
Australia, 1987
Gelatin silver print, 10³⁄₁₆ x 11¼ [51]

Mary Ellen Mark (United States, 1940)
Vashira and Tashira Hargrove, Twins—H.E.L.P. Shelter, Suffolk, New York, 1993, from *New York Portfolio I, Mother Jones 1998 Fine Print Portfolio*
Gelatin silver print, 10½ x 13¹⁄₁₆ [52]

Wayne Miller (United States, born 1918)
Afternoon Game at Table 2, 1948
Gelatin silver print, 10 x 12⅞, printed later [42]

Richard Misrach (United States, born 1949)
Road Blockade and Pyramid, 1989
Chromogenic print, 9½ x 12⅛ [24]

Denny Moers (United States, born 1953)
Poetic Origins in Mexico #1, 1982
Toned gelatin silver print, 17¾ x 16 [35]

Charles Moore (United States, born 1931)
Birmingham Riots, 1963
Gelatin silver print, 9⅛ x 13⅛ [45]

Inge Morath (United States, born 1923)
Encounter on Times Square, 1957, from *New York Portfolio I, Mother Jones 1998 Fine Print Portfolio*
Gelatin silver print, 13¼ x 9⅞ [67]

Abelardo Morell (United States, born Cuba, 1948)
Camera Obscura Image of a Pine Tree in Bedroom, Little Deer Isle, Maine, 1999
Gelatin silver print, 18 x 22⅜ [29]

Barbara Morgan (United States, 1900–1992)
Martha Graham, Lamentation (Oblique), 1935
from *Founders and Friends, Aperture at 50 Portfolio*, Platinum palladium print, 9⅝ x 7½, printed by Sal Lopes, 2002 [98]

Barbara Morgan (United States, 1900–1992)
Spring on Madison Square, 1938
Multiple-print photogram, gelatin silver print, 13⅝ x 16½, printed 1980s [3]

Graham Nash (United States, born England, 1942)
Self-Portrait in the Plaza, 1974
Iris print, 10½ x 16, printed 2001 [76]

Arnold Newman (United States, 1918–2006)
Alfred Stieglitz and Georgia O'Keeffe, An American Place, 1944
Gelatin silver print, 10 x 8, printed later [83]

Arnold Newman (United States, 1918–2006)
Allen Ginsberg, 1985
Gelatin silver print, 10¼ x 12½, printed later [87]

Arnold Newman (United States, 1918–2006)
Mary Ellen Mark, Rockport, Maine, 1993
Gelatin silver print, 13½ x 18⅝ [75]

Kenda North (United States, born 1951)
Patty, 1985, from the *Backyard Desire* series
Dye transfer print, 9⅝ x 18 [95]

Paul Outerbridge, Jr. (United States, 1896–1958)
Reclining Nude, 1923
Platinum print, 5½ x 7⅛ [109]

Gordon Parks (United States, 1912–2006)
Ingrid Bergman at Stromboli, 1949
Gelatin silver print, 8½ x 10, printed later [78]

Scott Peterman (United States, born 1968)
Long Beach, circa 2001
C-print, 17¾ x 22½ [23]

Peter Ralston (United States, born 1950)
Pentecost, July 1983
Iris print, 20 x 13⅝ [1]

Jane Reece (United States, 1869–1961)
Have Drowned My Glory in a Shallow Cup, 1919
Platinum print, 6 x 8, printed 1996 [97]

Verner Reed (United States, 1923–2006)
DAR, Newbury, Vermont, 1953
Gelatin silver print, 9⅜ x 6½, printed later by Joe Muir [60]

Doug Rhinehart (United States, born 1939)
St. Ann's Door, 1979
Gelatin silver print on board, 9½ x 9½ [39]

Doug Rhinehart (United States, born 1939)
Journey, 1984
Gelatin silver print, 12⅞ x 8¼ [101]

Leland Rice (United States, born 1940)
dis POSSESS, 1987–1990, from *Berlin Wall* series
Cibachrome print, 19⅞ x15 [36]

Kosti Ruohomaa (United States, 1913–1961)
Night Scene with Barn, circa 1951
Ferrotyped gelatin silver print, 5⅜ x 5⅛, printed late 1970s [38]

Marilyn Ruseckas (United States, born 1959)
April 11, #1, 1980
Selenium-toned silver print, 7 x 4¾ [103]

Sebastião Salgado (Brazil, born 1944)
Tigre, Ethiopia, 1985
Gelatin silver print, 11⅛ x 17½, printed 1989–90 [44]

Peter Shellenberger (United States, born 1966)
Danny, Myself, and the Shave, 1994
3 gelatin silver prints mounted on board, 18¾ x 12½ (each image) [105]

Jessica Shokrian (United States, born 1963)
Untitled, 1985
gelatin silver print, 7 x 10 [104]

Jessica Shokrian (United States, born 1963)
In the Back of Beyond, 1999
Gelatin silver print, 10⅜ x 10⅜ [58]

Edward Steichen (United States, 1879–1973)
Heavy Roses, Voulangis, France, 1914
from *Edward Steichen: Early Years, 1900–1927*
Photogravure, 8 x 10⅛, printed by Jon Goodman, 1981 [6]

Edward Steichen (United States, 1879–1973)
Three Pears and an Apple, Paris, 1921
from *Edward Steichen: Early Years, 1900–1927*
Photogravure, 12½ x 9⅞, printed by Jon Goodman, 1981 [4]

Edward Steichen (United States, 1879–1973)
Charlie Chaplin, New York, 1925
from *Steichen Twenty-Five Photographs Portfolio*
Selenium-toned gelatin silver print, 13³/₈ x 10½,
printed by George Tice, 1982 [70]

Paul Strand (United States, 1890–1976)
Wall Street, New York, 1915, from the *Aperture
Foundation Portfolio*
Photogravure, 10½ x 12½, printed by
Jon Goodman, 2002 [7]

Paul Strand (United States, 1890–1976)
Rebecca, 1923, from *Aperture's 50th Anniversary
Founders and Friends Portfolio*
Platinum palladium print, 7½ x 9½, printed by
Sal Lopes, 2002 [11]

Joyce Tenneson (United States, born 1945)
Italy, 1984
Cibachrome print, 12⁷/₈ x 19¾ [99]

Edmund Teske (United States, 1911–1996)
Jim Morrison and Pam, 1969
Gelatin silver print mounted on board,
10½ x 10¾ [79]

Edmund Teske (United States, 1911-1996)
Box Canyon, 1972
Gelatin silver print, 4¾ x 6½ [34]

Reed Thomas (United States, born 1937)
Ghost and Door, Pescadero, circa 1978
Gelatin silver print mounted on board, 12 x 9⁷/₈ [26]

Jerry Uelsmann (United States, born 1934)
Small Woods Where I Met Myself, 1967
Gelatin silver print, 10⁵/₈ x 12¾ [108]

Jerry Uelsmann (United States, born 1934)
Untitled, 1988
Gelatin silver print, 10¼ x 13½ [40]

Justin Van Soest (United States, born 1965)
Women's Powder Room, Radio City Music Hall, 1999
C-print, 12⁵/₈ x 18 [28]

Roman Vishniac (United States, born Russia,
1897–1990)
Granddaughter and Grandfather, Lublin, 1938
Gelatin silver print, 10½ x 10¼, printed 1977 [64]

Alex Webb (United States, born 1952)
Grenada, 1979
Cibachrome print, 16 x 20 [43]

Todd Webb (United States, 1905–2000)
Harry Callahan, 1941
Gelatin silver print, 4³/₈ x 3¼ [88]

Todd Webb (United States, 1905–2000)
Man Ray, 1951
Gelatin silver print, 8¹/₈ x 6³/₈ [80]

Todd Webb (United States, 1905–2000)
Georgia O'Keeffe, Twilight Canyon, Lake Powell, Utah,
1964
Gelatin silver print, 11¾ x 9¾, printed later [89]

William Wegman (United States, born 1943)
Untitled, 1988
Gelatin silver print, 6³/₈ x 6½ [63]

Edward Weston (United States, 1886–1958)
Nude, 1936
Gelatin silver print, 9³/₈ x 7½, printed later by
Cole Weston [9]

Minor White (United States, 1908–1976)
*Bill LaRue at Brett Weston's House, Carmel Highlands,
California*, 1959
Gelatin silver print mounted on board, 9⁷/₁₆ x 8¹³/₁₆ [102]

Max Yavno (United States, 1911–1985)
Cable Car, San Francisco, 1947
Gelatin silver print mounted on board, 15½ x 17½ [10]

Jay York (United States, born 1956)
Danya at the Quarry, 1993
Cibachrome, 13 x 13 [110]

Additional works by Judith Ellis Glickman
(United States, born 1938)

Joyce Tenneson, 1983
Gelatin silver print, 9¼ x 5¼ [Page 11]

*Bohusovice Train Station at Theresienstadt,
Czechoslovakia*, 1991
Infrared gelatin silver print, 13¼ x 19⁵/₈ [Page 10]

Jerusalem, Mea Shaearim, 1992
Gelatin silver print, 9 x 13³/₈

Reflection, 1995
Gelatin silver print, 13⁵/₈ x 10 [Page 11]

Venice, 1997
Gelatin silver print, 9¹/₈ x 13½ [Page 8]

Snow Geese, Quebec, 1998
Infrared gelatin silver print, 9¼ x 13⁵/₈ [Page 4]

Auschwitz, 1998
Gelatin silver print, 19 x 13⁷/₈ [Page 13]

Greek Islands, 2002
Cibachrome print, 13 x 19½

Untitled, 2002
Gelatin silver print, 13¼ x 8¾

Coretta Scott King, 2003
Gelatin silver print, 9½ x 6¾ [Page 142]

Centro Habana, Cuba, 2003
Gelatin silver print, 13 x 19⁷/₁₆

Further Reading The following titles provide an overview of recent exhibitions and publications about private photography collections in the United States.

Blessing, Jennifer. *Speaking with Hands: Photographs from The Buhl Collection.* New York: Solomon R. Guggenheim Museum, 2004.

Brookman, Philip, Merry A. Foresta, Julia J. Norrell, Paul Roth, and Jacqueline Days Serwer. *Common Ground: Discovering Community in 150 Years of Art.* Washington, D.C.: Corcoran Gallery of Art and London: Merrell Publishers Limited, 2004.

Bruce, Chris and Andy Grundberg. *After Art: Rethinking 150 Years of Photography. Selections from the Joseph and Elaine Monsen Collection.* Seattle: Henry Art Gallery, University of Washington, 1994.

Chasanoff, Allan. *Tradition and the Unpredictable—The Allan Chasanoff Photographic Collection.* Houston: Museum of Fine Arts, 1994.

Corcoran Gallery of Art. *A Book of Photographs from the Collection of Sam Wagstaff.* New York: Gray Press, 1978.

Denecke, Silke, Anne Ganteführer, Manfred Heiting, Susanne Lange, and Claudia Schubert. *Degrees of Stillness, Photographs from the Manfred Heiting Collection.* Corte Madera: Ginkgo Press, 1998.

Fels, Thomas Weston. *O Say Can You See: American Photographs, 1839–1939; One Hundred Years of American Photographs from the George R. Rinhart Collection.* Pittsfield, Mass.: Berkshire Museum and Cambridge, Mass.: MIT Press, 1989.

Foresta, Merry A. *American Photographs: The First Century from the Isaacs Collection in the National Museum of American Art.* Washington, D.C.: National Museum of American Art, Smithsonian Institution Press, 1996.

Grundberg, Andy. *Modern Photographs: The Machine, The Body, and The City; Selections from the Charles Cowles Collection.* Miami: Miami Art Museum of Dade County Association, 2006.

Haworth-Booth, Mark. *One Hundred Photographs: A Collection by Bruce Bernard.* London: Phaidon Press, 2000.

Haworth-Booth, Mark, Peggy Roalf, Adam D. Weinberg, and Marianne Wiggins. *From the Heart: The Power of Photography—A Collector's Choice, The Sondra Gilman Collection.* Corpus Christi: Art Museum of South Texas and New York: Aperture, 1998.

Janis, Eugenia Parry. *To Collect the Art of Women, The Jane Reese Williams Photography Collection.* Santa Fe: Museum of Fine Arts, Museum of New Mexico, 1991.

Keller, Judith and Anne Lacoste. *Where We Live: Photographs of America from the Berman Collection.* Los Angeles: The J. Paul Getty Museum, 2006.

Kirstein, Lincoln and Jerry L. Thompson. *Quarry, A Collection in Lieu of Memoirs.* Pasadena: Twelvetrees Press, 1986.

Lahs-Gonzales, Olivia, Lucy Lippard, and Martha A. Sandweiss. *Defining Eye: Women Photographers of the 20th Century; Selections from the Helen Kornblum Collection.* St. Louis, Mo.: St. Louis Art Museum, 1997.

Morton, Robert, and Margaret Donovan, ed. *Photodiscovery, Masterworks of Photography 1840–1940, [Collected] by Bruce Bernard.* New York: Harry N. Abrams, 1980.

Museum of Modern Art. *A Personal View: Photography in the Collection of Paul F. Walter.* New York: Museum of Modern Art, 1985.

Sinsheimer, Karen. *An Electic Focus: Photographs from the Vernon Collection.* Santa Barbara, Calif.: Santa Barbara Museum of Art, 1999.

Sischy, Ingrid. *Chorus of Light: Photographs from the Sir Elton John Collection.* Atlanta: High Museum of Art and New York: Rizzoli International Publications, 2000.

Sobieszek, Robert A. *One Man's Eye: Photographs from the Alan Siegel Collection.* New York: Harry N. Abrams, 2000.

Ware, Katherine and Peter Barberie. *Dreaming in Black and White: Photography at the Julien Levy Gallery.* New Haven: Yale University Press and Philadelphia: Philadelphia Museum of Art, 2006.

White, Stephen. *Parallels and Contrasts: Photographs from the Stephen White Collection.* Albuquerque: University of New Mexico Press, 1990.

White, Stephen and Andreas Blühm. *The Photograph and the American Dream, 1840– 1940.* Amsterdam: Van Gogh Museum, 2001.

Acknowledgments

142

Exhibitions, just like collections, take time and patience to assemble. The staff of the Portland Museum of Art has had ample opportunity in recent years to become acquainted with the photographs in Judy Glickman's collection and to learn more from her about the reasons for their acquisition. This exhibition attempts to provide museum visitors with a similar experience—pulling together the pieces, making visual connections, and finding the big picture. We are first and foremost grateful to Judy Glickman for that opportunity. Not only does her collection bring us works by nationally recognized photographers, but it shines a light on photographers in our own backyard who deserve much more attention. Numerous members of the photographic community in Maine contributed their images and insights to the exhibition, and we would especially like to thank Melonie Bennett, Barbara Goodbody, and Betsy Evans Hunt, who have encouraged Judy in her collecting endeavors over the years.

The production of any catalogue is always a group effort, and for this one we assembled a team with a special affinity for photographic projects. Both Margo Halverson and Charles Melcher of Alice Design Communication have worked as photographers. Sandra Klimt and Thomas Palmer have collaborated on numerous photographic books and delivered images that come as close as possible to the originals. The resulting book is a lasting record that replicates the organization and character of this particular exhibition. I would also like to thank William Hasted of Hasted Hunt Gallery in New York, who provided references for the bibliography on contemporary photography collectors.

And, as always, I am grateful to my colleagues at the Portland Museum of Art who helped to edit and proof the catalogue; provided graphic design support for the exhibition; matted, framed and installed the exhibition; organized the education and public programs; publicized the entire project, and continue to manage the collection on a daily basis: Dana Baldwin, Amber Degn, Tom Denenberg, Gretchen Drown, Julia Einstein, Allyson Humphrey, Stuart Hunter, Kris Kenow, Teresa Lagrange, Kristen Levesque, Sage Lewis, Karin Lundgren, Tamara McElroy, Vanessa Nesvig, Daniel O'Leary, Stacy Rodenberger, Jessica Routhier, Lauren Silverson, Ellie Vuilleumier, and Greg Welch.

Susan Danly
Curator of Graphics, Photography, and Contemporary Art

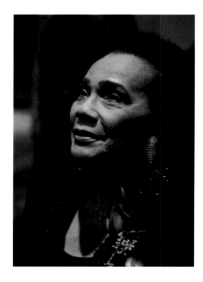

Judith Ellis Glickman, *Coretta Scott King,* 2003

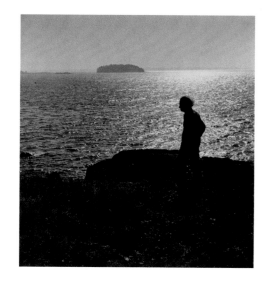

George Daniell, *John Marin, Cape Split, Maine,* 1952